**THINK
SMALL**

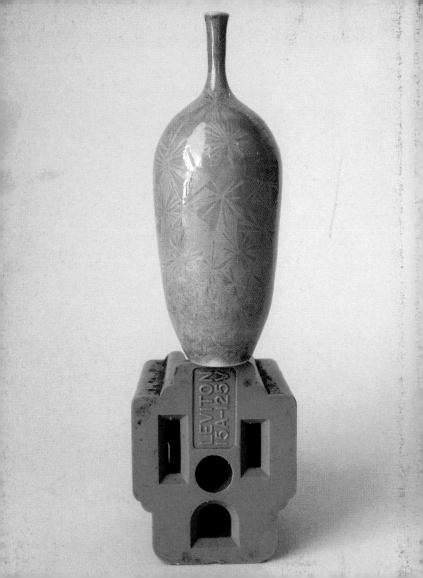

THINK SMALL

The Tiniest Art in the World

By Eva Katz

CHRONICLE BOOKS
SAN FRANCISCO

Library of Congress Cataloging-in-Publication Data available.

ISBN: 978-1-4521-5696-5

Manufactured in China.

Design by Lizzie Vaughan and Taylor Roy

10 9 8 7 6 5 4 3 2 1

Chronicle books and gifts are available at special quantity
discounts to corporations, professional associations, literacy
programs, and other organizations. For details and discount
information, please contact our premiums department at
corporatesales@chroniclebooks.com or at 1-800-759-0190.

Chronicle Books LLC
680 Second Street
San Francisco, California 94107

www.chroniclebooks.com

Opposite art by Zoe Keller
Cover art by Salavat Fidai
Page 2 art by Jon Almeda

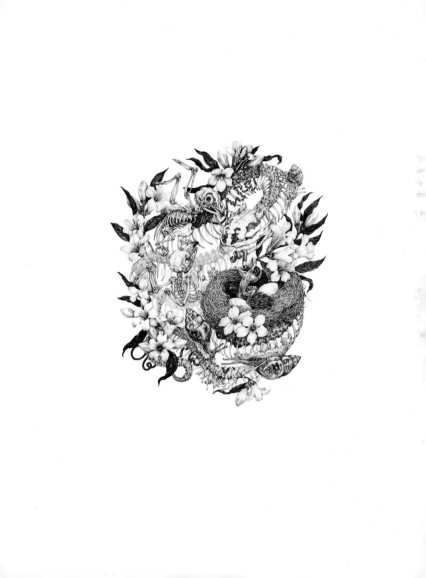

CONT

ENTS

INTROD

The artists in this book all work SMALL. Actually, in their cases, small is an understatement. Think tiny. REALLY REALLY TINY. This is artwork so small that it causes viewers to do a double take. Wait, really? It's *that* small? Are you sure? How did she (or he) *do* that?! How is that even possible? Am I seeing things?

The ability to work on VERY-SMALL-SCALE artworks requires a great deal of patience and expertise. And yet, despite the many obstacles, there are artists who choose to dedicate their time to working on the SMALLEST of canvases and with the MOST MINISCULE of mediums. What inspires artists to go so small? Is there perhaps a certain type of personality—perhaps one bordering on obsessively detail-oriented— that finds itself drawn to the making of TEENY TINY artworks? What makes an artist look at a sunflower seed or the lead of a pencil and see a canvas? What possesses someone to recreate a piece of iconic mid-century modern design in the SMALLEST homage possible?

TINY art is not a new phenomenon; it has been documented since humans first began painting on caves, going back at least thirty-five thousand years at Maros on the island of Sulawesi in Indonesia. In the eighteenth century, there was an artist who created astoundingly SMALL and detailed pieces; Matthew Buchinger was a German-born calligraphist, magician, artist, and musician despite the fact that he had neither hands nor feet. In 1718, he painted a portrait of Queen Anne that was a mere 5 x 7 in (12.5 x 18 cm). But if that doesn't

UCTION

sound SMALL enough, consider that the curls of the queen's hair are comprised of letters that contain verses from the book of Kings. The letters are SO SMALL that you wouldn't know that they were there, save for the fact that the museum that houses this treasure provides magnifying glasses. Blink and you probably don't see that the looping lines of miniscule handwriting that wrap around the oval frame are actually full chapters from the same liturgy.

The internet is a great way to connect people. For an artist, it can serve as equal parts inspiration and gallery show. Artists with healthy social media presences interact with fans from across the world who may not otherwise see their work. All it takes is for one art website to post an artist's work and the followers multiply as rapidly as bees in a hive. Many of the artists featured in this book are not formally trained, and quite a few have day jobs that aren't typically creative. What started as hobbies have grown into serious artistic practices, with bodies of work that garner enormous followings on social media. A design blog can share pictures from a Romanian architect and suddenly doodles made during free time manifest themselves into an entirely new career!

Think Small is a window into the minds of premier MINIATURISTS worldwide. Through galleries of their work and artist interviews, we peer into their jewel-like worlds of energy and whimsy, creative discipline and extreme patience. These are artists at the absolute top of their games, whose exquisitely SMALL work is a miracle.

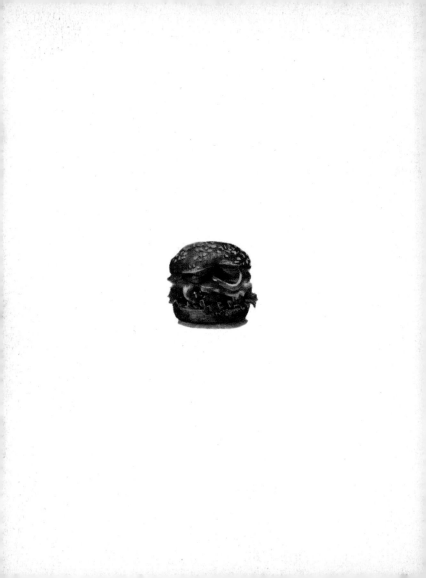

LORRAINE LOOTS

IS A South African–based artist and creator of *365 Postcards for Ants*. Why ants? When Loots began her foray into small canvases, she was constantly asked why she was painting on such a small scale. Her response was always the same: she was painting them for ants. What else would provoke Loots to pick a 10 x 10 cm (4 x 4 in) scale and paint images that are sometimes only 8 mm high? Don't think it's because they can be made quickly. Each piece can take between six and eight hours and sometimes up to nine—and all of this with nary a magnifying glass in sight. Loots works strictly with watercolors, for now.

Q&A

HOW DID YOU COME UP WITH THE IDEA FOR THIS SERIES?
Ironically, the idea came about after I had decided that I didn't want to pursue a career as an artist after all. I didn't want to stop painting, though, so I constructed this borderline OCD project where I had to spend an hour a day creating something. The only thing I could finish in that time frame was a miniature, and so *365 Paintings for Ants* was born. *365 Postcards for Ants* is now the second phase of that project.

WHEN DID YOU COME UP WITH THE IDEA FOR THIS SERIES? In late 2012, I was doing a business course for artists at the University of Cape Town School of Business. After three months of learning about tax, negotiating, marketing, and business plans, I decided that I did not want art to be my career after all. I also knew that I didn't want to stop producing art, and besides, I still had to come up with a business plan to pitch as my final assignment for the course I was doing. And so, *365 Paintings for Ants* was born. The plan was simply that I would set aside an hour a day outside of my "real job" to complete an artwork.

WHY DID YOU TITLE THE PROJECT PAINTINGS FOR ANTS? WHAT SIZE ARE YOUR PIECES? The pages I'm working on are about 10 x 10 cm, and the images themselves vary from 8 mm to 3 cm (1 in) in diameter. When I just started doing miniatures, people would say, "Oh, that's nice. But what would you do with something that small?" I just started saying they were made for ants.

WHAT INSPIRES YOUR DAILY CREATIONS? At first, I would paint whatever I felt like: everyday objects, or whatever I came across that day. But as people started reserving dates for me to paint for them exclusively, they got excited about the prospect of being able to make suggestions for what would be painted on their day, and I liked the idea of drawing inspiration from that. In 2014, I decided to structure it more carefully, limiting the suggestions to Cape Town-related themes and accepting no fewer than five suggestions per date. This ensured that I could still choose something that resonated with me, and at the same time, it prevented the project from becoming purely commission based. For 2015's project, I decided to pick four of my favorite themes and paint whatever I felt like on the day. I needed a bit more flexibility after two years of nonstop painting.

HAVE YOU ALWAYS PAINTED ON SUCH A SMALL SCALE? No, but I've always loved detail. Painting smaller pictures just allows me to put in the amount of detail I want to (otherwise, it would take me a lifetime). I also love the intimacy of it—the fact that you have to get so close to the image to really appreciate it.

HOW LONG DOES EACH PIECE, ON AVERAGE, TAKE TO CREATE? At first, I would have to paint them in an hour or two, but now that it's become a full-time job, I allow myself to indulge and will sometimes spend up to nine hours on one miniature. In general though, between six and eight hours.

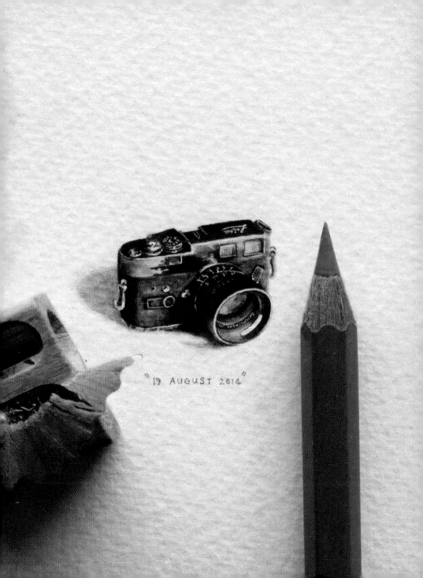

"19 AUGUST 2014"

"13 SEPTEMBER 2014"

DINA
BRODSKY

IS AN American contemporary realist miniaturist, painter, and curator. After a few failed attempts at art classes in high school, she ended up as an art major at the University of Massachusetts Amherst by a happy accident—she didn't know what else to do at school, but with her first painting class, she was hooked, and knew that this was what she wanted to do, every day, for the rest of her life. Brodsky later got her MFA from the New York Academy of Art, a school that specializes in bringing together a contemporary art discourse with traditional painting techniques. She hails from Minsk, Belarus, but now lives and works in New York. Brodsky has participated in solo and group exhibitions in galleries across the United States and worldwide.

Q&A

WHAT COMPELLED YOU TO GO TO SUCH A SMALL SCALE?
Honestly, I have always been more comfortable with a small scale—my first experience with art education was when my mother brought me to the studio of an artist friend of hers—I must have been about five—and he gave me a large sheet of paper and told me to draw. I started on a drawing that took about an inch of the paper, he told me to work bigger, and I was completely incapable of it—he told my mother that there was nothing he could teach me (possibly meaning that I was hopeless). Later, at university, and at graduate school, I was constantly told to paint bigger as well, and I complied but it always felt forced. I think I am just happier with a miniature scale. Also, because I live in New York where space is limited, the scale works for practical reasons as well.

CAN YOU GUIDE US THROUGH YOUR PROCESS FROM IDEA TO COMPLETION? I tend to work in series, each one exploring a single idea, and taking anywhere from a year or two to complete. Usually the idea for the next series comes to me during moments when I am away from my studio and my daily routine—when I travel, preferably by bicycle, and have time to completely clear my head. I then let the idea grow roots for a few weeks before beginning a series, because I know that once I start, it's going to be something that I live with every day for the next year or two.

ARE YOU EVER TEMPTED TO GO BIGGER? No, I am not, although I admire, and am occasionally jealous of, artists who work on an epic scale.

WHAT INSPIRES YOU? Everything. I believe that life is infinitely interesting, and if I look closely at anything I can turn it into art (maybe by the very act of looking and observing and consciously paying attention). The only way to answer this question without sounding incredibly vague is that I believe there are artists who are inspired by what is happening inside their mind, and there are those who are inspired by what's happening outside it. I belong to the second category—I find inspiration in watching, listening, and processing the things that happen around me, whether it is a conversation in a coffee shop, the changing sky during a bicycle ride, or the sunrise hitting a street at an angle that makes me see it in a different way.

WHAT'S NEXT? I don't know. I am currently in the middle of a project that involves 126 portraits of trees, and in the middle of a project it's hard to think of anything but what I'm working on at the moment. I do know that no matter what happens, I will keep painting, keep drawing.

GIULIA
BERNARDELLI

WORKS AS a museum educator during the day, and spills her coffee and makes masterpieces in her free time. She grew up surrounded by books and art; her father owns a bookshop and art gallery in Mantua, Italy. It was no surprise that Bernardelli ended up studying at the Academy of Fine Arts in Bologna and currently works in a museum. She is fascinated with colors, compositions, and detail.

Q&A

WHAT INSPIRES YOU? I see art all around me. Everything that I need is around me, if I look carefully. I decided to replace the paintbrush with what nature offers, such as leaves, fruit skins, food. All these elements feature different colors and textures.

CAN YOU GUIDE US THROUGH YOUR PROCESS? I never plan my creations in advance; I simply follow my instinct, based on the actions I perform. For instance, when I drink coffee, I start thinking of the nuances it would create if I dropped it on the table. At breakfast, I imagine a cat's paws treading on jam and leaving footprints.

WHY COFFEE? I started using coffee by chance. About a year ago, I accidentally knocked over a cup of coffee and suddenly a new world appeared, made of beautiful shades, each one different from the next. In my images I try to catch the magic of a moment, as if the coffee created a story by toppling. I love spontaneity, the ephemeral, the magic.

YOUR ART IS MOSTLY IMPERMANENT. HOW DOES THIS FEEL AS THE CREATOR? Most of my creations are temporary: they are eaten and they therefore disappear. This is an essential feature of my work. After I create an artwork, I take a picture, and this becomes the perfect end result. This is how the artwork is captured at its best, in the moment of final wonder. What I do is nothing but the product of a game, a curious look, a constant exploration. Creativity belongs to those who are able to show it and to make it an enriching and joyful way of life. I first started sharing my creations on Instagram (@bernulia) and I received positive feedback. This is where it all started, by sharing images.

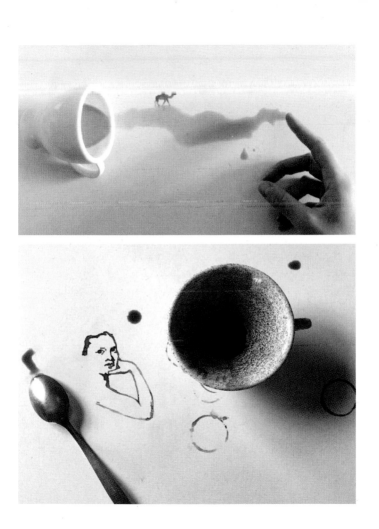

DANIELLE CLOUGH

IT'S HARD to describe Danielle Clough's creative disciplines without using a hyphen at least once. For example, she's a photographer-designer-embroiderer. Clough completed her studies in art direction and graphic design at The Red and Yellow School before embarking on a career in visual art, digital design, and "thing-making." Her combined interests in art, music, and South African street culture led to an experimental stint turned niche gig creating visuals for live music events. Using the stage name Fiance Knowles, Clough has performed with local DJ artists Haezer, PHFAT, Los Tacos, and Amy Ayanda and international acts such as the Allah Las, Apashe, Cid Rim, and Black Sun Empire. She hails from Cape Town, South Africa, where she currently works, plays, and bikes.

Q&A

WHAT COMPELLED YOU TO GO TO SUCH A SMALL SCALE? I really wanted to challenge myself, so I started sewing really big and teeny tiny at about the same time. I saw some embroidery pendants online and thought that would be a good way to dictate how small to start. I love the super small work because I can do it anywhere.

CAN YOU GUIDE US THROUGH YOUR PROCESS FROM IDEA TO COMPLETION? I create the line work on the fabric and then mount it in a small hoop. I "color it in with thread," and then mount it into a frame or wooden hoop.

ARE YOU EVER TEMPTED TO GO BIGGER? I work at all sizes, and my next goal is to go MASSIVE!

I FIND IT SO INTERESTING THAT YOU WORK BIG AND SMALL AT THE SAME TIME! WHY IS THAT? IS IT HARD TO SWITCH BACK AND FORTH? TALK TO ME! I like working at different scales because the challenges vary, and this keeps it really exciting! It's not that difficult to change the scale, but every size has its obstacles. The back and forth helps me learn from these obstacles, and improve.

WHAT INSPIRES YOU? I'm usually inspired by colors, photography, new materials, and tools. I find inspiration and motivation are two very different forces in any creative work. Inspiration is like the strong flash of energy. It's the enthusiasm. I am motivated to follow through with these moments of inspiration for very different reasons, mainly so that I can live every day making something that I am passionate about.

DO YOU SEW WITH MUSIC PLAYING? SINCE MUSIC IS SUCH A BIG PART OF YOU, I WONDER IF IT'S PART OF YOUR CREATIVE PROCESS. I don't actually! I leave that for the night. If I'm not at a coffee shop stitching, I'm in a mess of threads watching a movie or series.

WHAT'S NEXT? I want to sew my way around the world.

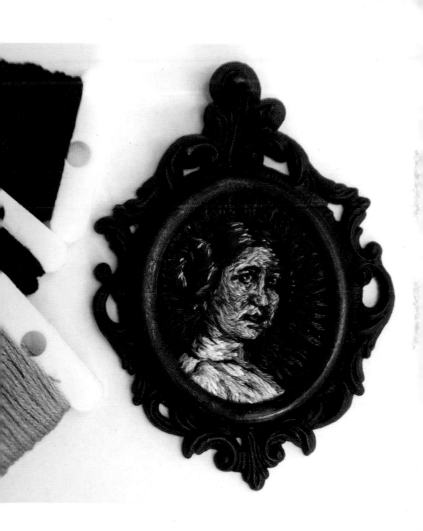

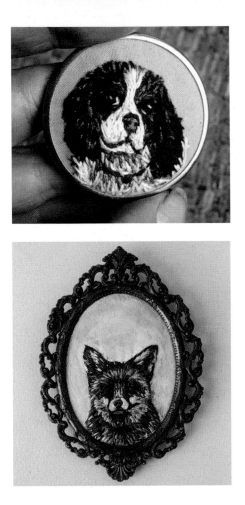

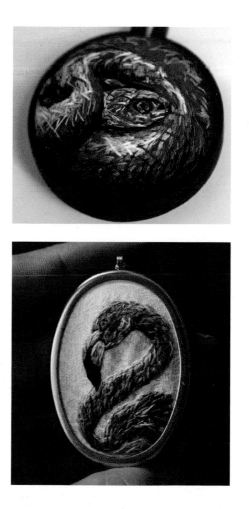

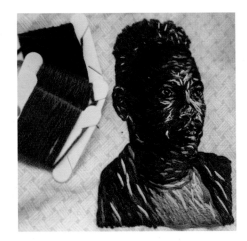

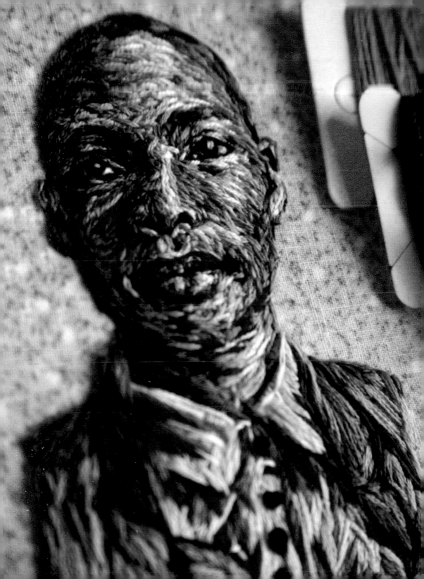

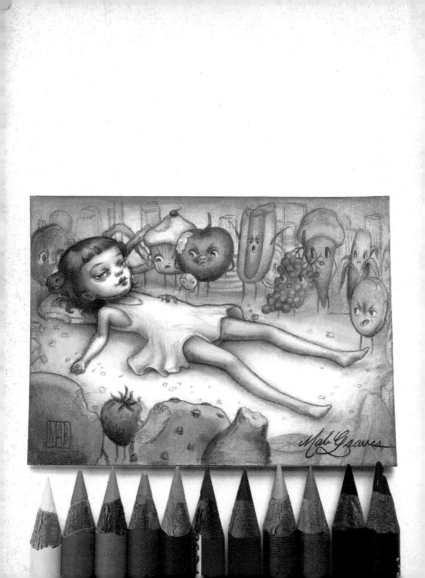

MAB
GRAVES

IS A contemporary pop-surrealist artist and illustrator living and painting in a converted 1800s tavern in a small corner of the dusty American Midwest. She's a self-taught artist, inspired deeply by science, dinosaurs, retro space, '60s kitsch, and fairy tales. She adores narrative and symbolism, and stories are an important part of her work. Her passion for creation has been an overwhelming obsession since she could grip a crayon, at about the age of six months. Mab's work has been shown in galleries and sold in fifty-eight countries. She currently lives, works, and dreams in Indianapolis, Indiana.

Q&A

WHAT COMPELLED YOU TO GO TO SUCH A SMALL SCALE? Ever since I was little I have had a passion for tiny things. The smaller, the better. The reason why I learned to paint so small came from pure necessity. I was really poor, working two day jobs and painting at night. I had no studio, so I would paint sitting on the floor with an upside-down milk crate as a desk. With a tiny lamp, my palette, and rinse water all crammed on top of the crate, I had probably less than 6 in (15 cm) of space to work in. I realized either I was going to have to limit myself to only painting small things (like flowers and seashells. Snooze! +o+) or I would have to teach myself to shrink my world. I didn't want my dreams and my art to be limited just because my space was. So I became a miniaturist.

CAN YOU GUIDE US THROUGH YOUR PROCESS FROM IDEA TO COMPLETION? I'm a self-taught artist, so I don't have a very sophisticated system. It starts with the inspiration. That becomes the idea, and the idea comes to me as pretty much a fully formed image. All of a sudden a painting will piece itself together and pop into my mind like the last scene in a detective movie (the aha moment!). It's usually totally out of the blue, when I'm not expecting it. Sometimes it's so sudden it takes my breath away.

From there I'll do a couple of weeks of research on specific elements—a lot of my pieces are inspired by science, so I'll read books, listen to lectures, and make sketches of any special details and symbolism I want to include in my pieces. If I'm embarking on a new series, I

normally take a trip to the Museum of Natural History for a few days of intense research. After that, I start painting!

ARE YOU EVER TEMPTED TO GO BIGGER? I do sometimes! A couple of years after I started painting, we moved into our current place. It's an old tavern from the 1880s that we converted into a loft/double studio space (my partner is also an artist: larryendicottphotographic.com). Now that I have the space to work, I can go bigger when I want to. At my core I will always be a miniaturist—and even my "big" work is considered pretty small by the rest of the world: 8 x 10 in (20 x 25.5 cm) is a "large" painting for me. ^_^

WHAT INSPIRES YOU? I constantly get inspired by things around me, totally random things. One time I created a painting after seeing a chunk of cement in some weeds while I was driving. Out of the corner of my eye it looked strange and wonderful. You never know what will hit you. It totally depends on my mood or what I'm into at a given time, but my mainstay muses are ALWAYS science, fairy tales and stories, astronomy, natural history, nerd stuff (*Star Wars* and *Star Trek*), and all things '60s kitsch.

WHAT'S NEXT? I'm currently working on my next project, *The Children of the Nephilim*, a series of oil paintings of little dark-winged girls and dinosaurs in sherbet-colored prehistoric landscapes.

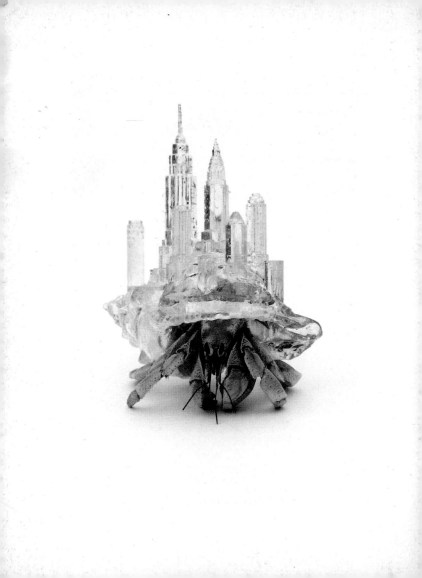

AKI
INOMATA

COMPLETED HER graduate studies in intermedia art at Tokyo University of the Arts. She exhibits her work in various parts of Japan, where she currently resides, and across the globe, with exhibitions in Poland, London, and beyond.

Q&A

WHY WORK SMALL? My works are not always miniature in scale. This study, *Why Not Hand Over a "Shelter" to Hermit Crabs?*, is inherently small, so it is naturally a miniature-size work.

WHY ANIMALS? My art is undertaken as a collaborative work with animals. I recapture humans from different angles and try to rediscover the meaning of self by identifying our world within a creature's behavior. I also say that it is like a "theatrical performance," with the creatures acting out the role of humans.

CAN YOU TELL US MORE ABOUT YOUR THOUGHT PROCESS? After I come up with an idea, I do research over and over again, and then I build my making method. There are often times that my art is not completed because my work is built on the collaboration with creatures, and they are not under my control. We never know whether it will succeed. There are also some projects I have no choice but to drop because of production costs.

HOW MUCH TIME IS INVOLVED FROM START TO FINISH? A lot! For example, it took two and a half years for me to collect my hair and that of my dog for my work *I Wear the Dog's Hair, and the Dog Wears My Hair*. It also took several years for me to catch bagworms for my work *girl, girl, girl. . .*

It is hard to say when it is clear that my work is completed. Occasionally, my project becomes an ever-changing work even though it is already completed, especially when it is part of an ecological exhibition.

DID YOU ALWAYS WANT TO BE AN ARTIST? I'd wanted to be an artist since I was a child, and I hope to share my work in the world. My work is not like a painting or sculpture, but is about an action and how it is received, so it is important to present it and receive feedback.

WHAT'S NEXT? I'm working on a project with clams, and also the project with hermit crabs is still ongoing. I have several other projects in progress, so I'll continue to work hard so people can see them soon.

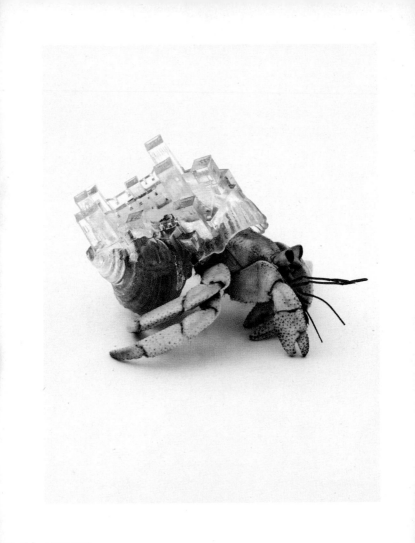

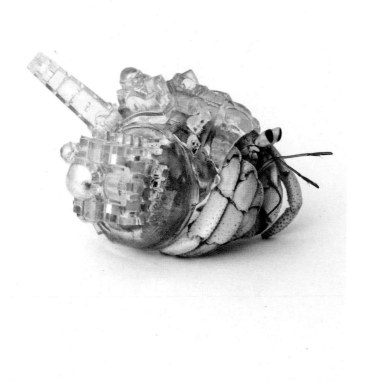

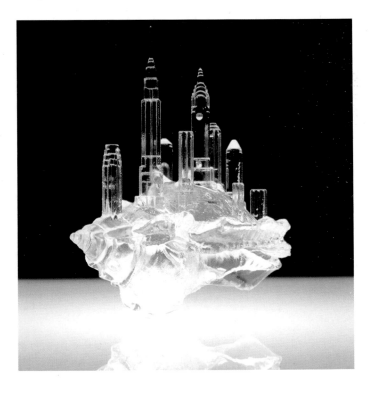

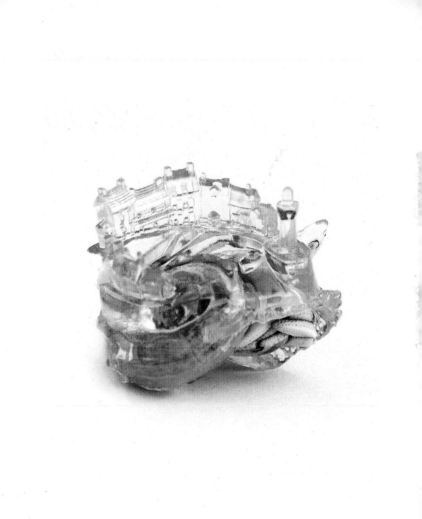

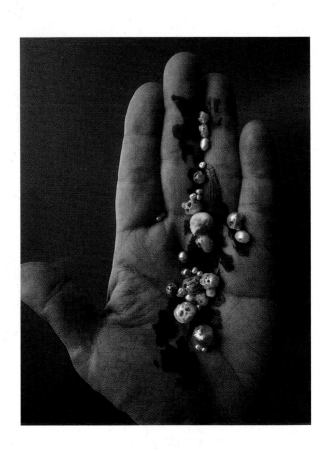

SHINJI NAKABA

IS A self-taught artisan of jewelry engraving and metal work. Traveling the world, from the British Museum to the Metropolitan Museum of Art in New York, and scouring Italy specifically to see antique cameos, Nakaba is always researching. His research has also brought him to Kofu, Japan, a place well known for Japanese crystal sculpture, leading him to translate an obscure technical manual on jewelry making found at an antiquarian bookstore in Tokyo. Once the translation was complete, it was time to practice the methodology described. Nakaba says, "For me, the best way to learn is to look for great examples, and this is also the quickest way to learn the technical language for jewelry engraving."

Q&A

WHY WORK SMALL? I feel happy every time I place a miniature object on my palm. When I was little, I loved playing with tiny furniture and cars in a sandbox. I still carry those childhood memories, and perhaps that has inspired me to work on a small scale. Also, I enjoy the feeling that I am like an almighty god of my tiny world when I manipulate my tiny objects.

CAN YOU TALK ABOUT YOUR PROCESS? I don't use a perfectly sphere-shaped pearl when I carve it into a skull because it is easier for me to see an image on the pearl if it is a bit disfigured. I stare into the pearl first, and often a small bulge and a dent open up the appearance of a forehead and a cheekbone, and then I can see the swelling of the back of the head on the other side of the pearl. I start drawing the image with a felt-tip pen directly onto the pearl to keep it visible, and then I start carving. Shaping teeth and carving my signature require a lot of my attention, and I need to concentrate fully when I am working on those parts. A little bit before the project is done, I usually start working on a new project for a while. This gives me a mental break and refreshes my perception of the project, and it allows me to reevaluate the work to see whether I have transferred something of my essence to it.

WHAT DO YOU HOPE TO ACCOMPLISH WITH YOUR ART? I hope to gain a larger audience for my work so that more people can see it, because I'm doing this for a living. I feel lucky that times have changed for the better, because now I can show my work not only at exhibitions and galleries but also use the internet to talk with my clients and sell my work directly. With so many large issues facing our world, such as the economy, conflicts between countries, and terrorism, I believe it is time for people to let the old systems go and realize that what is most important is to enhance the potential for all people to live happy and productive lives.

WHAT'S NEXT? Lately, I have the feeling that it is my mission to prove that I can make any type of material—whether it is gold, platinum, metal, paper, or trash—equally beautiful through my jewelry. I want people to look at my jewelry and understand that we don't need to spend a lot of money or use up the natural resources of the earth to have a nice life; it is possible to create the latest fashions without them. I'd like my work to spread the message that we are able to have a bright future if only we could use our creativity.

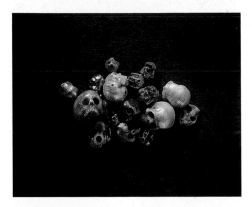

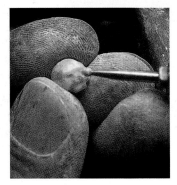

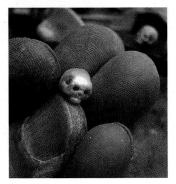

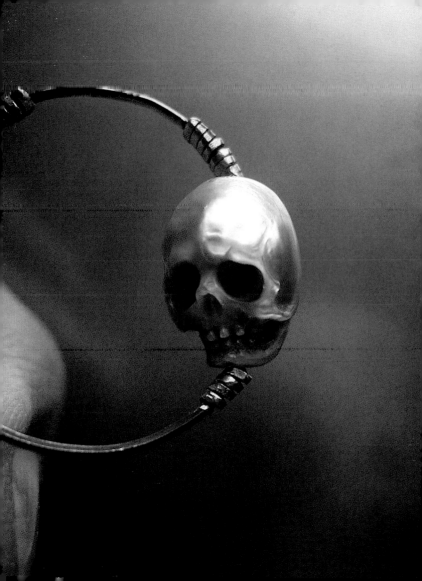

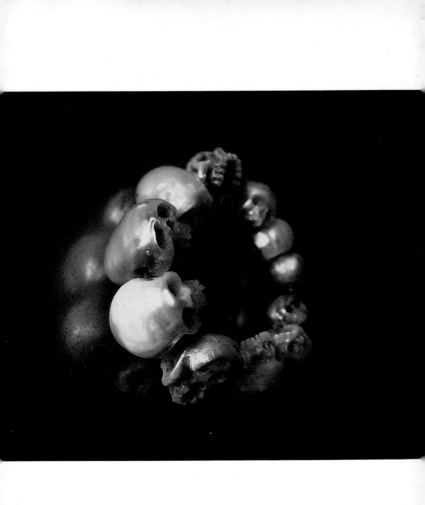

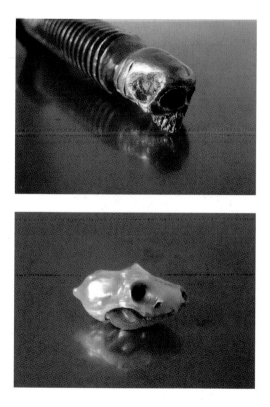

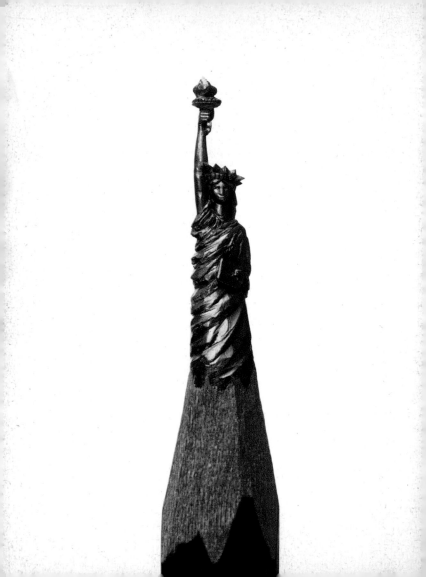

SALAVAT
FIDAI

IS A self-taught artist who launched a full-time art career after a sudden layoff due to an economic crisis in Russia. Both of his parents are professional artists, so perhaps this pivot in Fidai's career makes perfect sense. Fidai recalls making his first micro sculptures as a child, carving them out of chalk at school.

Q&A

WHAT IS YOUR PROCESS LIKE? The concept for my paintings and sculptures starts to take form while I'm asleep. The next day, I look for photos and video material, and then I make sketches or layouts. When I work with oil on canvas, it's more emotional and expressive. If I paint acrylic on seeds, it's hard work and more detail oriented. When I carve sculptures from pencils, it's much more meditative. Under the glow of a single work light while my family sleeps, I use a craft knife and a 4x magnifying glass to create tiny sculptures out of pointy pencil lead. It takes six to twelve hours of work for an average sculpture. Complicated models take two to three days. The creations come in full view only after I use a macro lens and photograph them to reveal the great detail of faces, hands, and objects left by my slow, deliberate blade.

DO YOU PREFER WORKING AT NIGHT? I'm a total night owl. I find myself more productive, and it's much easier to focus at night. In my former job at an office, I worked only six hours a day. Now I work twelve hours a day, seven days a week. But I'm very happy. I spend most of that time in my home studio, creating miniature sculptures and paintings. I like to experiment in different areas of art: photography, painting, drawing, and sculpture. I love to create new ideas, trying new materials and subjects.

WHAT IS YOUR ALL-TIME FAVORITE CANVAS? My favorite canvas is the humble pumpkin seed; its smooth, white surface is perfect for tiny copies of Van Gogh's *Starry Night* or Vermeer's *Girl with a Pearl Earring* as well as a series of portraits based on characters from *Star Wars* and personalities from pop culture.

WHAT INSPIRES YOU? I do a lot of reading and go to other artists' exhibitions. Sometimes inspiration comes from my dreams, sometimes from the artwork of other artists, such as Van Gogh. I am inspired by good music. My children will be artists, too. My son learned pencil carving and recently sold his first carved pencil.

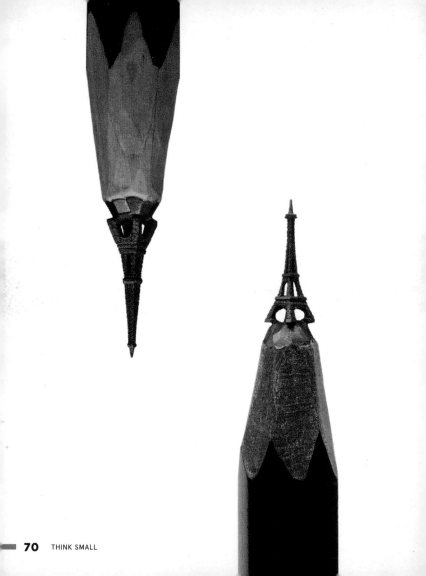

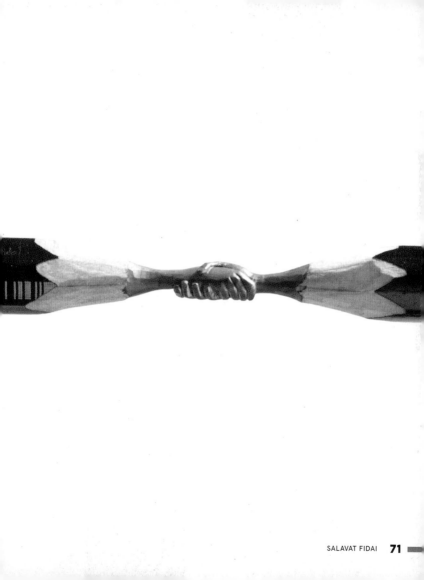

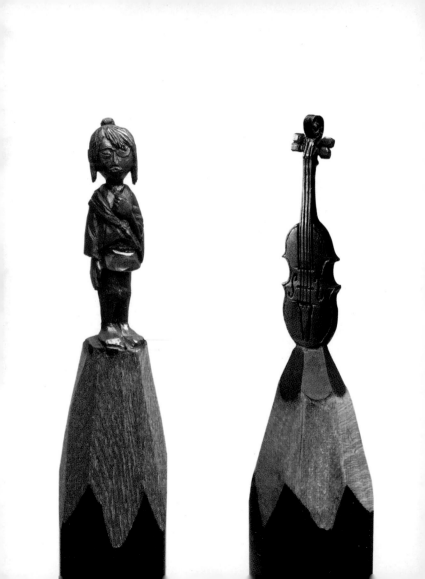

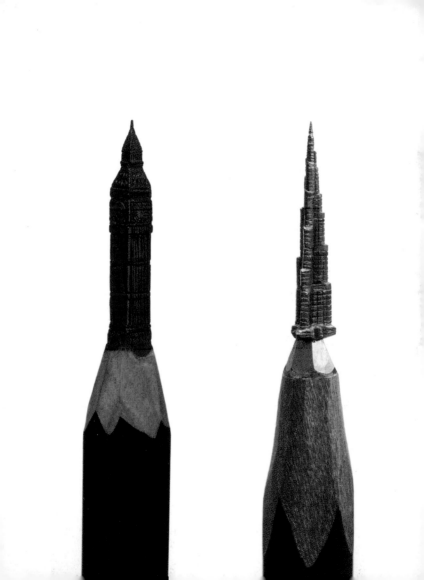

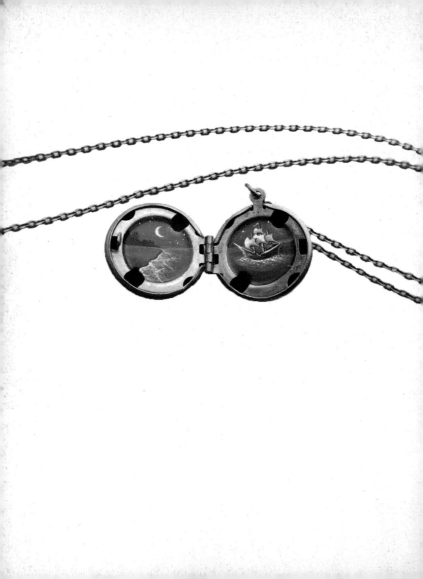

KHARA
LEDONNE

GOT HER start as a large-scale muralist and sign painter
for buildings all over New York City. After painting a mural at
one of New York's most iconic landmarks, the Empire State
Building, she hung up her muralist hat. It was this last gig that
"burned my passion for murals almost to a crisp." This led to
Ledonne's exploration of miniatures.

Q&A

WHAT COMPELLED YOU TO GO TO SUCH A SMALL SCALE?
Working on a small scale emerged from both living in New York and moving often. Living quarters are so tight! Do you want to make art or have a bookshelf? Choose one. Jewelry and miniatures were a slow experiment that didn't ask for too much space, and that I could carry with me each time I moved.

HOW DOES WORKING ON A MINIATURE SCALE DIFFER FROM YOUR MURAL WORK? Miniatures are a pleasing escape from murals and demand little in comparison. They are personal, private, and don't require scaffolding.

CAN YOU GUIDE US THROUGH YOUR PROCESS FROM IDEA TO COMPLETION? Most of my ideas begin with a challenge. Can I paint a brontosaurus in a locket? How about the entire solar system? It takes a few trials before a new design fits. I use oil enamel, which has a brief working window before growing tacky. First I paint a background color for the base of the painting. That thick layer needs a few days to dry well before adding detail layers. Then I add anywhere from three to ten thin layers of color and detail. A design like the solar system is most complex—each planet's color has to be mixed, highlighted, and shaded. Jupiter itself is three layers and five colors, and it's smaller than a peppercorn! I work on ten to twelve pieces at a time, painting by color as I mix each shade.

WHAT INSPIRES YOU? I'm terribly inspired by spontaneous adventure stories (maybe too much). Why not quit your job, burn your paintings, and backpack to Peru? That kind of thing. I love the idea of escape. I love the idea of meeting unexpected people with unexpected stories. Even if it's only in my mind, or in my miniatures, which is often where those landscapes manifest.

WHY LOCKETS? I love an object with more than one purpose. The painting is art. The locket is jewelry. Together it's a tiny escape capsule with a hidden world inside. To wear one is to carry a place only you know is there, secretly holding your private adventure or beloved place.

WHAT HAPPENS WHEN YOU MAKE A MISTAKE ON SUCH A SMALL CANVAS? Making a mistake on such a small canvas is to unleash a waterfall of curses, that's for sure! One reason I layer the paint so slowly is that I can approach each layer one at a time. If I've painted the base for a moon, but I smudge the gray layer of crater detail, I have ten minutes or so to wipe it off with mineral spirits. Then I can try the gray again without ruining the base. Occasionally, I just have to throw the bugger over my shoulder and start from scratch.

HAVE YOU EVER MADE A PIECE THAT HAS EXTRA-SPECIAL SIGNIFICANCE TO YOU, AND PERHAPS YOU COULDN'T PART WITH? There's a sailboat pendant that I painted a couple of years ago

that I couldn't part with. I have a deep nostalgia for the rocky coast of Washington, where I grew up, and the painting felt too personal to relinquish at the end. Little did I know I'd be looking at sailboats to live on a couple of years later. I guess that pendant knew something I didn't!

WHAT'S NEXT? In the coming year I'll be experimenting outside of the locket format. Compasses! Bracelets! I've also started a series of paintings on antique bottles from Dead Horse Bay, a beach scattered with turn-of-the-century debris from an eroding landfill. The paintings show a narrative of an ocean story—things like a ship sailing away with a tree house on deck, and a sailor playing in the air of a whale's spout, all about 1 to 2 in (2.5 to 5 cm) in size. I love working small, but I feel it's important to push the locket boundary.

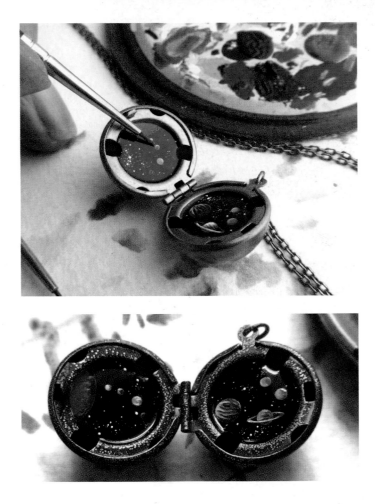

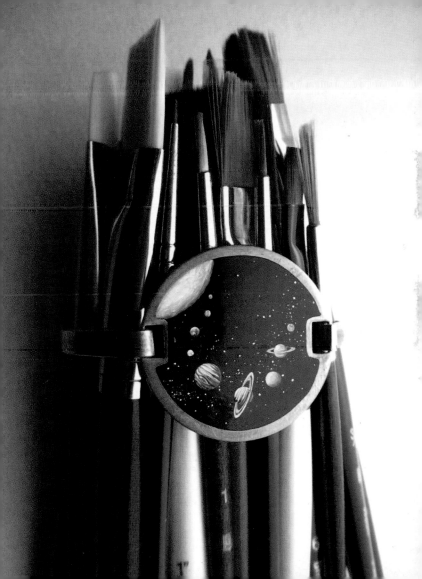

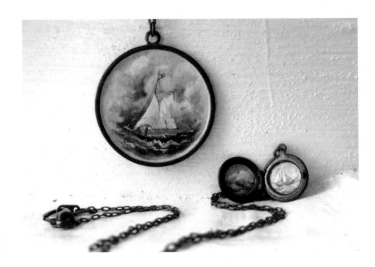

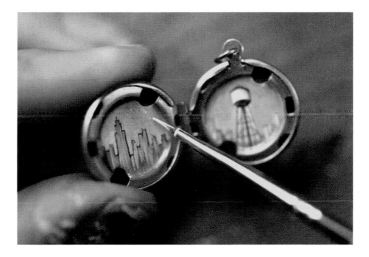

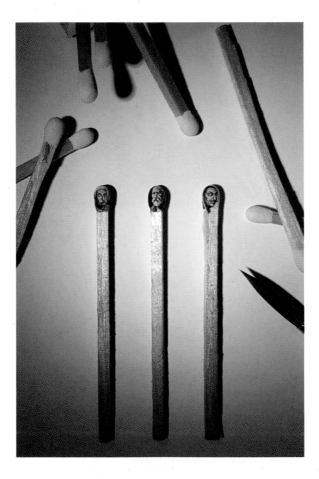

HASAN KALE

IS AN artist from Istanbul who seeks out challenging and unconventional canvases on which to paint landscapes of his native country, Turkey. Onion peels, pieces of chocolate, and even halved almonds are all fair game. He is planning on compiling all of his micro art into a museum with the goal of sharing his miniature work with the largest audience possible.

Q&A

WHY SMALL? I love transforming micro objects that we ignore and pass over in our daily lives into art capsules. I took this path so I could open new windows in people's minds, show alternative perspectives, and create an unprecedented language. Looking back right now, I see how right I was. It's quite enjoyable to see that what I've been doing for years became a trend in the end. I'm proud to be the only artist in the world who has used more than 300 different objects as my canvases, reaching new audiences with my extraordinary and unusual art. The best part is communicating with color, because I do not speak my viewers' languages. I don't need to, because colors speak their own languages.

WHAT IS YOUR PROCESS LIKE? First, I gather the objects that I intend to work with and put them on my worktable so I can be closer to them. A period of time passes. . . . In the meantime, I observe them closely. When the time comes, I decide which piece to work on. It's a tough period—choosing which colors to use on my palette, which themes to reflect on new canvases. The process depends on the difficulty of the object or subject. The least required amount of time is three days, and the longest one is around three months. If the object is new to me, it's usually troublesome. However, holding your breath (to not move the object) and waiting for the result of your effort is priceless.

ARE YOU EVER COMPELLED TO GO LARGER? Yes, I also work on large-size canvases. I work on projects on a variety of subjects. For instance, I'm also continuing my career as a jewelry designer. In addition, I'm involved in industrial design, and currently I'm working on motorcycle design.

WHAT INSPIRES YOU? I enjoy crowds. I feel alive. Istanbul is full of mystery. I always have a chance to observe and learn new things here, and I like taking on challenges. I believe that God gave me good hands, good eyes, and a big heart to work with. The only thing that matters to me is expressing myself with my micro works.

WHAT'S NEXT? My next goal is to found a new museum full of my micro artworks. I'd also like to show my work all around the world and reach new people, and publish a book with an exceptional style and language.

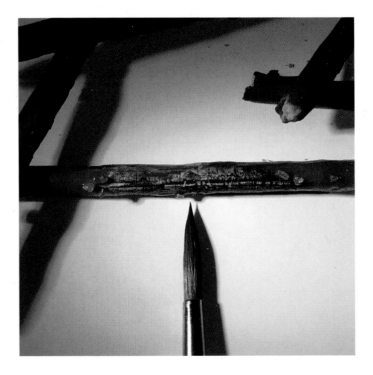

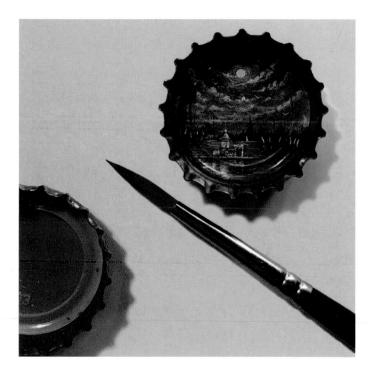

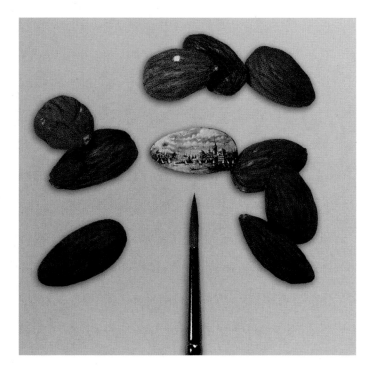

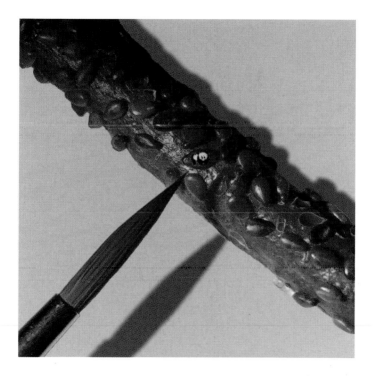

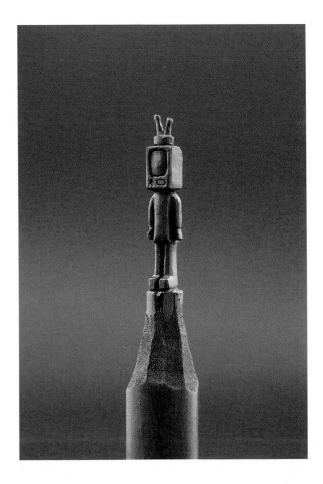

JASENKO DORDEVIC

(TOLDART)

IS COMPLETELY self-taught. He follows his own motto: Whatever you do in life, work and effort are necessary. With constant work you gain experience. Of course, you also need talent, but TOLDart thinks that talent plays a really small role: "I've probably inherited my talent. My uncle was a painter and my brother also has a gift for drawing." He has had many independent exhibitions and a dozen group exhibitions. Some of his works are on display at the Cumberland Pencil Museum in the United Kingdom, and one of his sculptures was gifted to the Hollywood actor Benicio del Toro. His art received two awards (the prize for sculpture and the Grand Prix) at the International Biennial of Miniature Art in Bosnia and Herzegovina.

Q&A

WHAT COMPELLED YOU TO GO TO SUCH A SMALL SCALE? Ever since I was a child I showed a propensity for art. For some reason, I was drawn to miniatures. I honestly don't know why; it might be the challenge that drives me or I'm just better with smaller things. When I was a primary school student, I always had a problem filling out the whole paper in art class. Even though I drew better than the other kids, and my drawings were always on exhibition, my teacher constantly reminded me to draw bigger pictures. I also liked making clay and paper sculptures, but there was the same problem: my sculptures were the tiniest. When I was in high school, I started making origami sculptures. Every time I made one I wanted it to be smaller than the last one. Then I made a little paper boat. The dimensions of the paper that I used to make the boat were 1.5 x 2.5 mm, while the boat itself was 1.7 x 0.7 mm. I applied to Guinness World Records, but because of some administrative problems they declined my application; however, they did confirm that they don't have a similar record.

WHY PENCILS? In January 2010, my brother sent me a link to the artist Dalton Ghetti and challenged me to try to make something like he does. I immediately accepted the challenge and two days later I sent him the finished sculpture. After that, I continued to make sculptures on pencils.

WHAT ARE THE DIMENSIONS OF YOUR ART? The dimensions of the pencil graphite are small, about 0.5 x 5 mm, depending of the type of pencil.

LEAD DOESN'T SEEM VERY FORGIVING. WHAT ARE SOME OF YOUR BIGGEST OBSTACLES? Graphite is really difficult to work with: it's hard and fragile at the same time, and you need a lot of patience. Besides that there is also a physical restriction, because you need to find an idea for a sculpture whose shape corresponds to the surface of graphite, and that's a big challenge every time you decide to make something. Currently, the biggest issue I have is visibility, because I make all of my sculptures without any optical tools. Even though I see very well, sometimes I'm not able to do the smallest details. Recently I made the letters TOLD on a 0.7 mm graphite. Now I intend to make a sculpture of this dimension, but I'm going to need some optical tools for this one.

HOW MANY WORKS HAVE YOU COMPLETED? Up until now I've made 150 to 200 sculptures. Most of them are gifted, some of them have been sold, and some of them broke due to carelessness. I have been in three independent exhibitions and a dozen group exhibitions.

CAN YOU GUIDE US THROUGH YOUR PROCESS FROM IDEA TO COMPLETION? Creating a sculpture can be divided into three phases. The first phase is the idea itself and preparations. When I have an idea, I first draw it in the form of a sketch as it would look on the pencil. Depending on the shape of the sculpture, I pick out the best tools and the place where the sculpture is the least fragile, which I use as the starting point. The second phase is the realization of the idea; that's when I start to shape the graphite. It takes me anywhere from five to

ten hours to get the rough shape, depending on the complexity of the sculpture. The way I work is I need to get the right shape no matter how much time it takes. It is mostly active work with minimal rests. When I am working, most of the time I listen to music because that helps me concentrate. I listen mostly to Nick Cave & The Bad Seeds as well as smooth jazz, acid jazz, blues, and other types of slow music. The third phase is the detail work. First I take a macrophotograph of the sculpture to see whether I have missed some details that I didn't see with the naked eye. Because I make my sculptures without any optical tools, it is really hard to see the small details. After I have seen which details need to be fixed and what needs to be improved, I finish my sculpture. For this process, I need a couple of days because I do the small details very slowly. Most of my sculptures are smaller than 1 cm and a 1 mm mistake is very big on such a small surface. Sometimes I have to make the same sculpture twice because the first one has a small mistake. After I am done with the sculpture, I take another macrophotograph of it and then I put it in a safe box or in a frame.

ARE YOU EVER TEMPTED TO GO BIGGER? No, and I don't think I will ever try. I get along just fine in small dimensions and I feel safe there. Besides, the miniature presents a great challenge to me and that is the reason I'm interested in that kind of art. Miniature as an art form is not represented that much, probably because a lot of people don't want to struggle with small dimensions.

WHAT INSPIRES YOU? I find inspiration in anything that surrounds me; it just needs to trigger my senses. The soul is involved, too; for example, there are a variety of shapes that can fit on a pencil lead, but most of the shapes I just don't feel. My inspiration comes in different moments. When an idea comes, I draw it, and later some of those ideas I make into a sculpture.

WHAT'S NEXT? For now I don't have any plans. I'll continue to push my boundaries. In addition to making sculptures I would like to craft jewelry, maybe a combination of wood and silver. I've been planning that for a while. For now, that's only a wish but in the near future it might even happen.

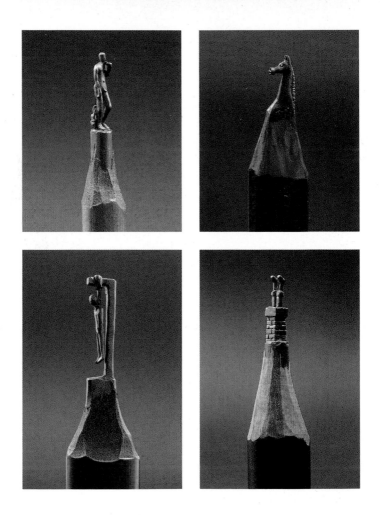

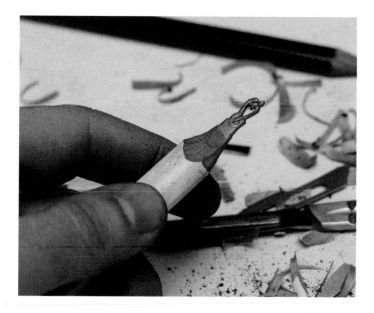

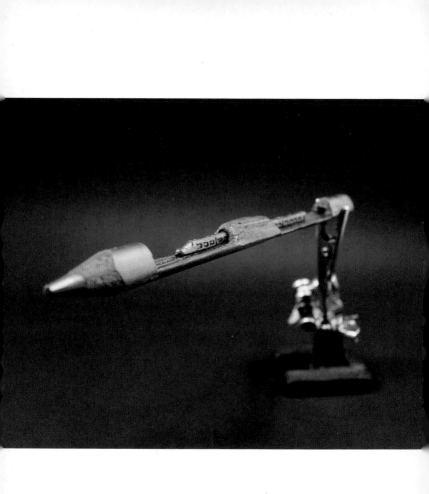

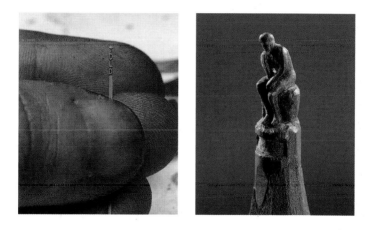

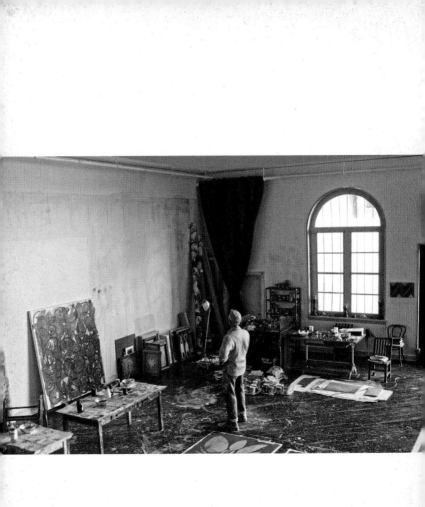

JOE FIG

IS AN artist and author known for his works that explore the creative process and the spaces where art is made. His paintings and sculptures are exhibited internationally and can be found in numerous museums and leading private collections. Fig received his BFA and MFA from the School of Visual Arts, New York City. He is represented by the Cristin Tierney Gallery in New York. Fig works and lives in Connecticut's Farmington River Valley with his wife and two children.

Q&A

WHAT COMPELLED YOU TO GO TO SUCH A SMALL SCALE?
Working in a small scale came to me out of desperation. I had been making life-size, large-scale paintings and literally came to an end with what I was interested in. So I did everything opposite to get out of the creative block. That initially led me to working small. Once I began working on that scale I came to embrace it. Working on a miniature scale gives the viewer a God's eye perspective and creates a sense of voyeurism. It allows me to create a vast area within a reasonable amount of space.

CAN YOU GUIDE US THROUGH YOUR PROCESS FROM IDEA TO COMPLETION? My work focuses on the artistic creative process and how and where art gets made. I start with a visit to an artist's studio. I conduct a formal interview with the artist that is recorded. The questions focus on their creative process and how they move and work within their space. From this information I can hone in on specific parts of the studio that I find of interest. From there I will photograph and measure everything within that space. With this reference material I then go back to my own studio and build a sculpture, in dollhouse scale, of that space or of a corner of the studio. The interview is integral to my process, as it informs which part of the studio I will depict.

ARE YOU EVER TEMPTED TO GO BIGGER? Of course, and I have. Working in a miniature scale can become very tedious at times. I find it helpful to switch gears and work on a larger scale, be it in painting or sculpture. I find the shift in scale relaxes my hands and opens my mind. It goes from working with your fingers and wrist to working with your whole body. It's physically a different process.

WHAT INSPIRES YOU? I'm inspired by people. Artists inspire me, as do people who are self-motivated and take a chance on themselves. I find artists to be some of the hardest working people I know. It can be a tough life, but I find the ones who are successful are the ones who persevere. Perseverance cannot be overrated.

WHAT'S NEXT? I'm currently working out some ideas for a new project. Nothing concrete. Some ideas are works based on the critique and art criticism—artists who are teachers and how they work with their students. And paintings that are closer to my home and personal life.

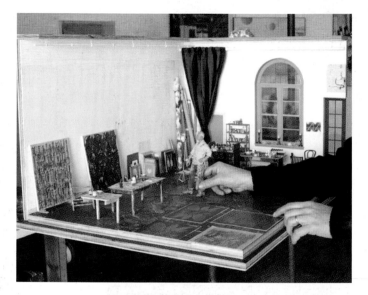

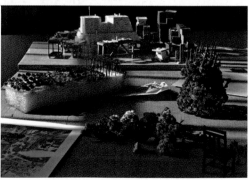

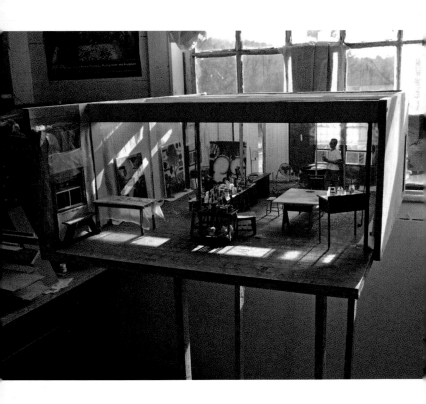

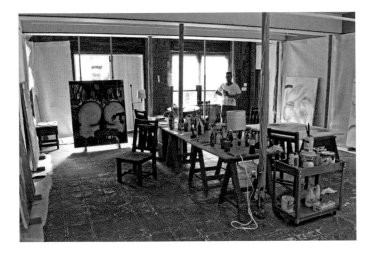

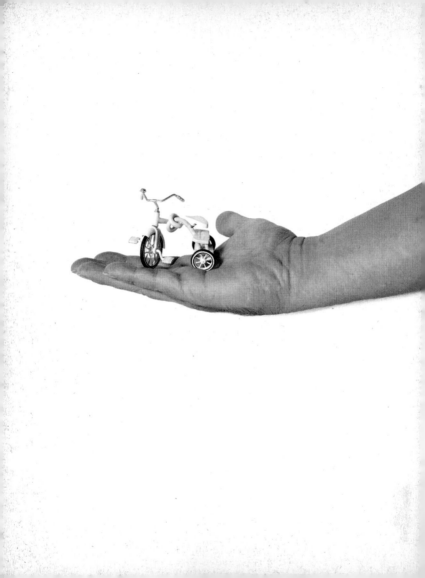

SERGIO GARCIA

IS A Los Angeles–based mixed-media artist. He got his start in the world of graffiti and street art, which led to airbrushing and custom paint jobs in the automotive industry—think motorcycles and lowrider vehicles. Garcia then made his way to galleries and exhibitions worldwide. His art has won several awards for its creativity and distinction.

Q&A

WHAT COMPELLED YOU TO GO SMALL? I like small because it's exaggerated and it's not normal. It makes people start thinking. How? Why?

CAN YOU GUIDE US THROUGH YOUR PROCESS FROM IDEA TO COMPLETION? I normally spend more time thinking about the concept and how to pull it off than actually executing it. I think a lot about the materials as well. What will be the strongest and lightest materials I can use?

WHERE DO YOU LOOK FOR INSPIRATION? I look for inspiration everywhere: people, hands, crowds, pictures, magazines, everyday life. I try to capture and sometimes add a twist.

WHAT DO YOU FEEL CHANGES ABOUT YOUR PROCESS WHEN YOU WORK ON LARGE-SCALE INSTALLATIONS VERSUS YOUR TINY PIECES? Not much changes in scale. Most of the times it's the process. Once I've done it before I learn what not to do and how to make it easier. I'm always jumping around from materials to learn different things and techniques. It helps me be creative and feel challenged.

ZOE KELLER

ATTENDED THE Maryland Institute College of Art, where she hopped from painting to illustration and finally to graphic design with a printmaking focus. Her first real post-college job at a graphic design firm completely destroyed her personal art practice, so she quit and joined an anarchist art collective in a remote town near the Canadian border. Keller spent the next year volunteering full time on the administrative end of their collaborative social justice projects. That magical year ended on a sad note, but, influenced by the practices of the artists she had supported, it also left her with a renewed interest in drawing. She spent the following year scribbling away all of her tangled, angsty feelings and fell for graphite as her primary medium.

Q&A

WHAT COMPELLED YOU TO GO SMALL? I dove into small drawings after spending the first half of this year working through a handful of 4 x 3 ft (122 x 91 cm) pieces. I enjoy the speed with which I can work through 4 x 6 in (10 x 15 cm) ideas, and am more inclined to take risks when I am gambling with a tiny piece of paper and only nine to fifteen hours of studio time. There's also the fact that I'm relying pretty heavily right now on the strange alchemy of transforming graphite drawings into groceries; working small means that my originals and prints are accessible to a wider audience.

CAN YOU GUIDE US THROUGH YOUR PROCESS FROM IDEA TO COMPLETION? My favorite drawings begin with lots of research. I can spend whole months just reading books and online articles, taking pages and pages of notes. I boil all of these words down to a few concepts that I find exciting, often combining my newly gleaned research with firsthand memories of the natural world. Next, I work out a composition through tiny indecipherable thumbnails. Once the composition is right, I move on to my final drawing surface and sketch out everything in light 2H pencil. Finally, I let my darker pencils spit out the fully rendered drawing in a generally inadvisable top-left- to bottom-right-corner fashion.

WHERE DO YOU LOOK FOR INSPIRATION? Outside, outside, outside! And also books, especially my growing rainbow of Audubon Field Guides.

WHAT DO YOU FEEL CHANGES ABOUT YOUR PROCESS WHEN YOU WORK ON A LARGER SCALE? My process is generally the same. What changes most, at least right now, is my anxiety level; working large is still incredibly intimidating to me. I will be showing my first large-scale work side by side with a collection of very small pieces at the end of this year, and I am interested to see how folks react to each end of the spectrum. I will pursue whichever direction has a greater emotional impact with my audience. I want to create work that makes people care more deeply about the natural world, so my connection with my audience is as important as, if not more important than, the runner's high kind of blissful exhaustion that comes from bringing a piece to completion.

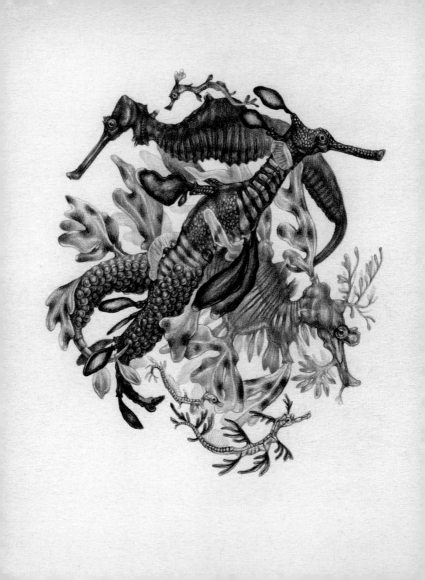

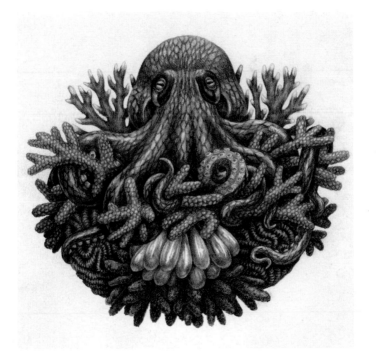

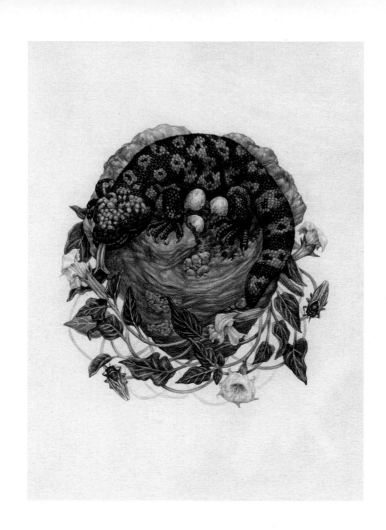

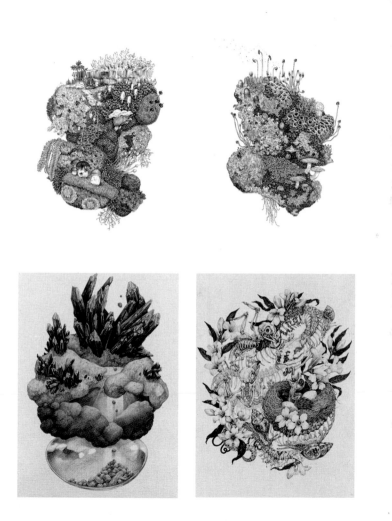

SHAY AARON

HAILS FROM Tel Aviv-Yafo, Israel. Aaron's background is in arts and theater; he recently completed set and costume design studies and has become a full-time stage designer. He has designed several shows, including one for the largest theater in Israel.

Q&A

WHAT COMPELLED YOU TO GO TO SUCH A SMALL SCALE?
I started making miniature pieces ten years ago. I used to create small-scale creatures, *Sesame Street* figures and other replicas of famous cartoons. I was asked by a client to create a miniature replica of the Passover Seder platter, and the rest is history. Once I made the realistic platter, I knew that I wanted to put my efforts into miniature food. What motivates me today is the challenge of getting a miniature replica to look the same as the real thing.

CAN YOU GUIDE US THROUGH YOUR PROCESS FROM IDEA TO COMPLETION? It all starts with an "inspiration board." I explore the Web in order to find lots of images of the food piece I'm about to create. I look for images that show the texture, the color, and the way it is served. I make some texture tests, which leads me to the finest result. The main material of my mini food is polymer clay, which is modeling clay, famously known as Fimo. I also combine lots of other materials in my work, such as resin, glass, wood, metal, and paper. I use ready-made tools, such as ceramic dishes, metal cutlery, and glass bottles. I prefer them as my clean canvas. When it comes to realistic food, I think it's important to use the same materials as the real thing. For instance, I know that I can't create a realistic fork out of metal material, so I use ready-made ones, but always keep them in the right scale, which is 1:12. I manage to work in this scale by using tools such as toothpicks and tweezers.

ARE YOU EVER TEMPTED TO GO BIGGER? As a set designer, I work on the design in a miniature black box, which has similar features as the theater I design for. It's called a "maquette." The maquette is a 1:25 scale model made by the set designer. The set model, with a book of sketches and blueprints, is sent to a factory, which builds the real 1:1 set design. Basically, it's a replica of my miniature model. In the past year I have had to think big, so each miniature model I create—from furniture to concrete walls—is going to be real and big on stage.

WHAT INSPIRES YOU? I find inspiration from my mother's kitchen to Martha Stewart. When it comes to food, the inspiration is endless. I get ideas from cookbooks, TV shows, and my clients all over the world, who ask for a replica of their favorite dish.

WHAT'S NEXT? Becoming a stage designer is a big dream, and this year is going to be all about that. At the moment I'm working on a new production, so I barely have time to focus on miniature making. I have some plans for working on a new miniature food collection, which I named *Food Around the World*, and to keep producing my food jewelry collection.

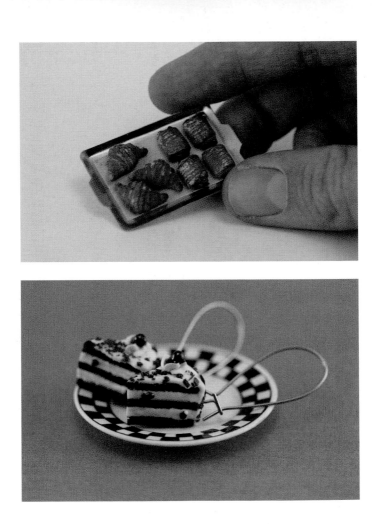

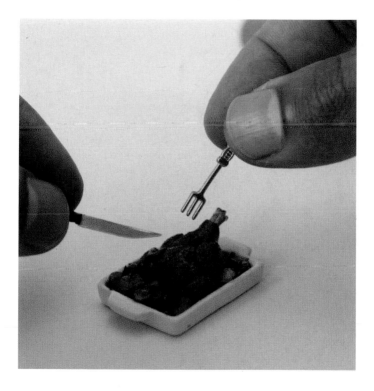

ANDRE LEVY

A.K.A. ZHION, is a Brazilian illustrator, art director, and visual artist based in Frankfurt, Germany. He communicates complex ideas with strong iconic visuals. Levy is influenced by the lowbrow art movement, pop art, comics, and urban art. He is equally at home with large corporate clients as he is with personal commissions.

Q&A

WHAT COMPELLED YOU TO GO TO SUCH A SMALL SCALE?
I think I started to pay more attention to small things when I moved from Brazil to Europe in 2011. Being a foreigner living in a new country for the first time made me feel surprised and excited again about things you don't normally think about. The initial inspiration came from the ordinary coins I carried in my pocket every day. After a short trip to London, I found myself loaded with a few Elizabeths from different ages that made me think about the practical value of those tiny metal sculptures outside of their territory of origin: basically none. It was the beauty of those British pounds that brought me to the idea of revealing other stories that could give each piece individuality and give myself a reason to keep them around.

CAN YOU GUIDE US THROUGH YOUR PROCESS FROM IDEA TO COMPLETION? I've been strongly immersed in pop culture since my early years. Cinema, comics, music, and video games are filled with strong narratives, and their characters' iconic visuals felt like a natural choice to replace the existing historical figures on the coins. I keep an updated list with characters I still want to portray, and I have an increasing collection of coins that I revisit every time I need a new face as a base. Some coins inspire which character will be painted because of some resemblance, but most of the time it works the other way around. Due to the kind of paint I use, the painting process varies from a couple of days to a couple of weeks, because every layer takes up to six hours to dry completely before I can come in with the next color. The more colors, the more time I need. In some cases, though, coins may stay unfinished for longer periods of time until I feel like finishing them.

ARE YOU EVER TEMPTED TO GO BIGGER? Going bigger for me doesn't mean changing the scale of my work, but improving my skills and, as a consequence, being able to communicate bigger ideas. *Tales You Lose* was very meta in its concept, because it helped me understand a lot about my own creative process, externalize my influences, and establish a relationship with the public. Many pieces went viral (for plenty of different reasons) and provoked discussions. Only the fact that a small painting that fits in my pocket can be inspiring to people of different cultures across the globe in some way is proof that size is really relative. We are small ourselves. Thinking about ideas based on their physical size feels a bit senseless to me.

WHAT INSPIRES YOU? Change will always inspire me. There will always be system flaws, injustice, manipulation, and invisible human-made forces holding us back from evolution and balance. If my art can open the mind of one person at least, that's enough inspiration for me to keep going on with it.

WHAT'S NEXT? When I started the coin paintings, I never could have predicted I'd end up with more than 200 pieces. The experience of learning a new medium during the creative process is very exciting and, most of the time, very rewarding. After this series, I feel much more confident about trying new materials and releasing myself from the limitations of digital illustration, which has been my main medium over the years, and that's what I've been focusing on since then. I love collaborating with other artists and having the opportunity to push each other out of our comfort zones. Thanks to that, I've done

sculpture, urban art, photography, and new printing techniques as a way to free my ideas from a specific style or format. My next goal is to inspire people to think more about what I show, rather than just like my work on social media.

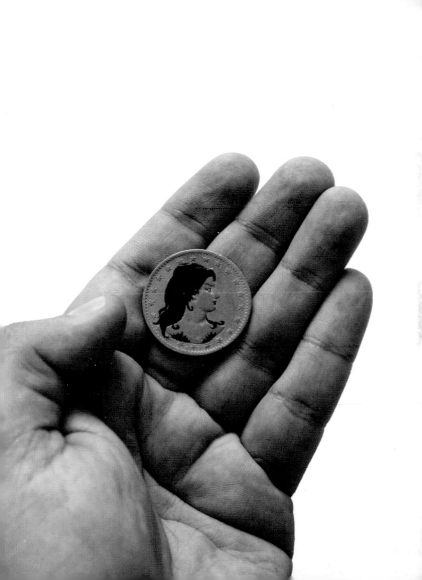

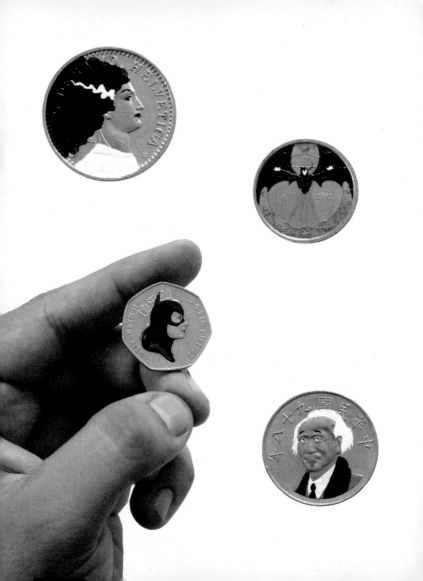

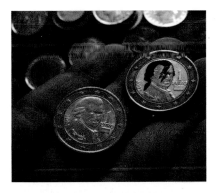

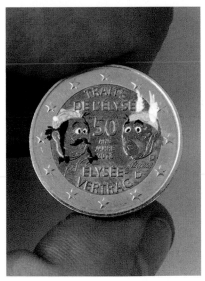

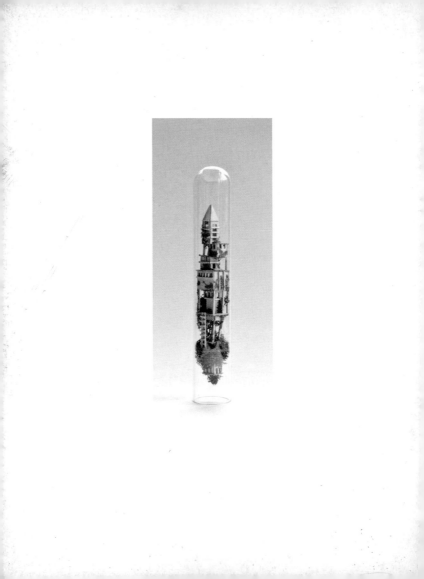

ROSA
DE JONG

STUDIED ART direction for advertising, but then she quickly started working with her own clients on projects that were more design oriented. Because she started in advertising, she learned to leave everything out that doesn't work for your story, the famous "less is more" approach. "I don't think this means everything should be clean and white," she says. "It just means that you should be aware of what's essential to your story and what is not."

Q&A

WHAT COMPELLED YOU TO GO SMALL? It's always interesting to take something out of proportion; it makes you look at an object differently. Since I live in a small apartment in Amsterdam it's not hard to see why I went small. Also, with this project, building a disproportionally big house is not really an option—those already exist.

CAN YOU GUIDE US THROUGH YOUR PROCESS FROM IDEA TO COMPLETION? Most of my ideas are made without a sketch or plan. Only when I have a specific idea do I try to make a quick sketch up front. Some of them almost make themselves; for example, if there's a branch that I think will make the most amazing tree, then I just have to build around it. Other objects need more time to decide what's right for them. I think the most planning is in just looking at the object, imagining the next step, thinking through different options, and deciding what's the best way to go. For tools, I use tweezers, a small knife, a paper knife, a triangle ruler, and patience. For materials, I use glass test tubes, cardboard, sticks, train model materials, wire, and sand.

WHERE DO YOU LOOK FOR INSPIRATION? Inspiration is a tricky thing. I love looking at things, mostly online, at design websites and sites like Pinterest, but it can also be discouraging looking at all these incredible things that are being made. For me, probably, most of my inspiration comes from my curious mind and interaction with other creatives I know.

Oh, and let's not forget nature.

WHAT DO YOU FEEL CHANGES ABOUT YOUR PROCESS WHEN YOU WORK ON LARGE-SCALE INSTALLATIONS VERSUS YOUR TINY PIECES? The bigger you go, the more detail you will need.

DOES WORKING WITH TEST TUBES EVER FEEL CONSTRICTING? A little. As an artist, I feel like I should renew myself constantly, instead of just making different versions of my former work. I am working on integrating light into the miniatures, something that doesn't work well with the test tubes because of the wires. So although I think the test tubes are what make this project stand out, I have also started building outside of them.

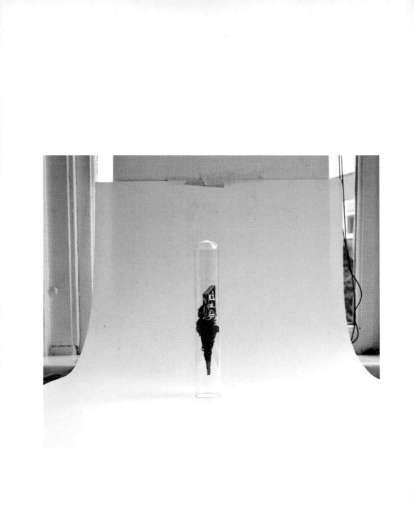

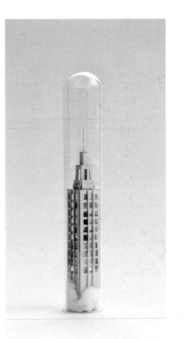

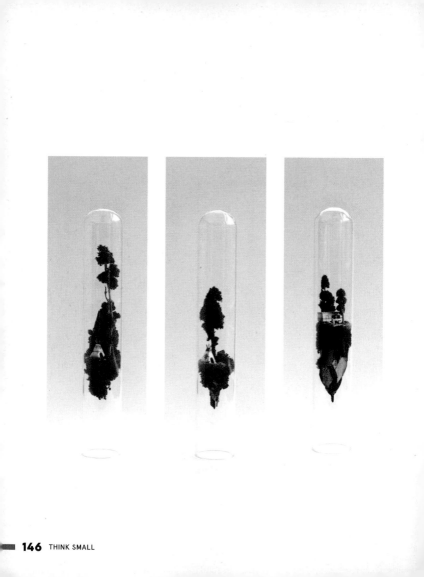

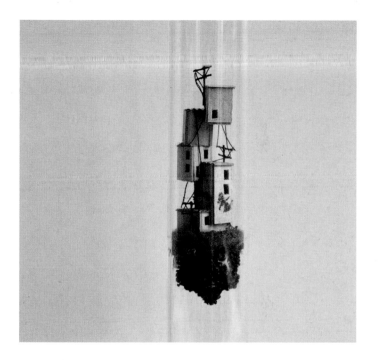

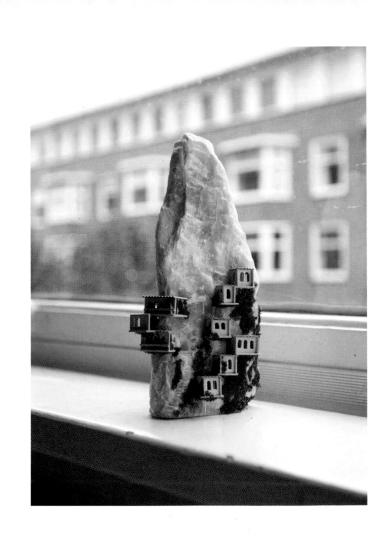

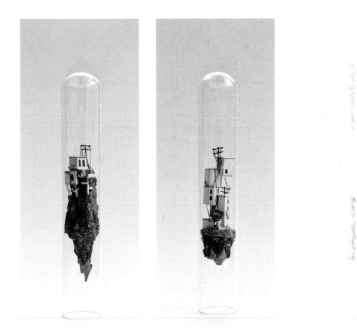

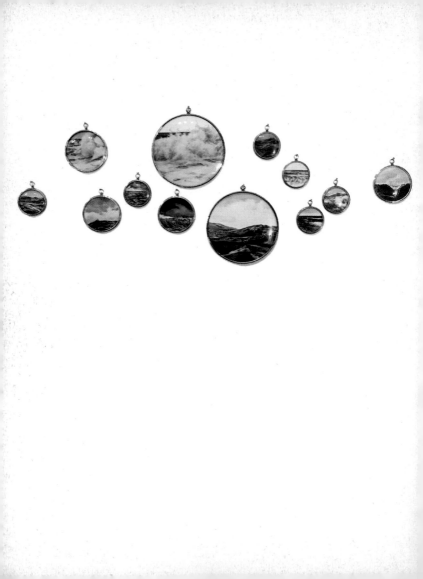

MARINE EDITH CROSTA

STUDIED AT the School of Fine Arts in Bordeaux, and this background provided her with much freedom and self-acceptance as a visual artist. However, she found the program far too conceptual. Crosta enjoyed the research part but got a bit confused when it became more about building your "artistic persona." Above all else, she admires craftsmanship and savoir faire much more than the eccentricity of some characters evolving in the art sphere. She thinks such a facade lacks authenticity and can be intimidating for people willing to invest in a piece of art. This is quite the opposite of what she's aiming to do with her collectors in this day and age.

Q&A

WHAT COMPELLED YOU TO GO SMALL? I started painting again after a long, long break. I had moved to London into a shared house, and I soon realized that being able to afford a studio was way out of reach then, and painting large pictures in a carpeted bedroom or in a shared kitchen was going to be complicated. So I went mini!

CAN YOU GUIDE US THROUGH YOUR PROCESS FROM IDEA TO COMPLETION? At the minute I'm lucky enough to have good exposure on my Instagram account (@marine_edith) and people keep sending me snaps of the sea—surfers from the Basque Country, sailors on the North Sea, or simply lovely peeps on holidays. I try and take hundreds of pictures when I'm traveling, too—my phone AND my boyfriend's are saturated with seascapes from everywhere! I then edit them, adjust the colors and contrast, launch a podcast, and start painting. Luckily, the minuscule scale allows me to block several paintings in one sitting, and then I come back to them and add details when they are dry. I frame them myself, with antique brass circles, as the round shape complements the sea quite nicely, I think. There is a lot of work involved there: it took me a while to figure out how to proceed, between sourcing the supplies and drilling, cutting glass, and so on.

WHERE DO YOU LOOK FOR INSPIRATION? My collectors inspire me a lot; they kindly share very personal stories with me. This happens very often and it makes it all worthwhile. I surround myself with kindhearted people, whether they are very spiritual, involved in charity, or politically aware, and this is very inspiring, too. I also used to

work in retail after getting my fine arts degree, and I did costumes for promos and advertising when I first moved to London, so I still keep a close eye on fashion and videos. I'm growing very fond of antiques and interior design as well, and I like to think that my pieces can be a nice gateway to this field, as I don't want to stick to one thing in terms of career. Never have done, never will.

WHY OCEANS? Maybe I miss being by the sea a bit too much? I say it will be the last one every time, but I'm currently painting *Lost at Sea 276*, and still having as much fun as with the first one.

WHAT DO YOU FEEL CHANGES ABOUT YOUR PROCESS WHEN YOU WORK ON A LARGER SCALE? It takes so much longer!

WHAT'S NEXT? I'm taking part in a few group shows and art fairs, but I need to slow down soon and focus on exploring new things. I find it almost impossible to say no to work. :)

I have such amazing responses online when I paint something different, and I can't wait to see what I will come up with next. I'm also a little bit terrified, to be completely honest, because I have no idea what it will be!

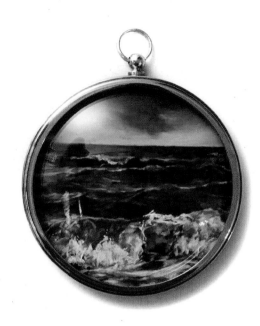

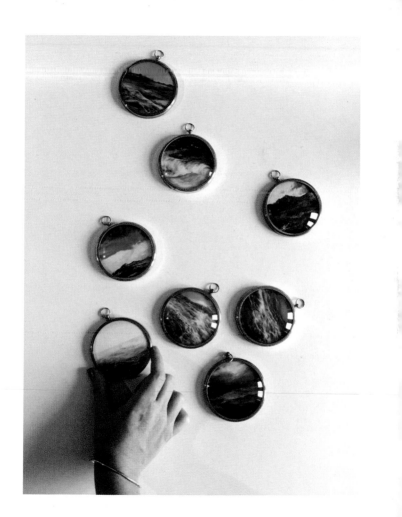

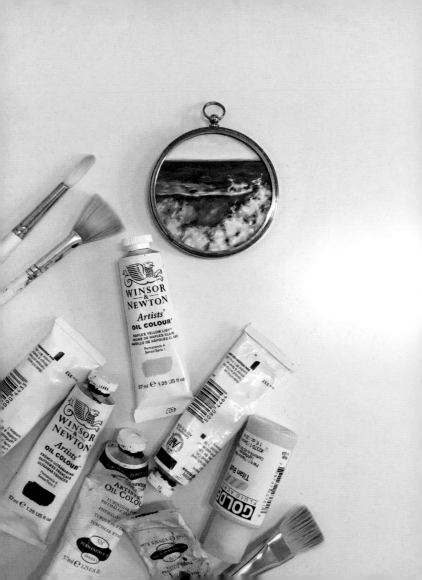

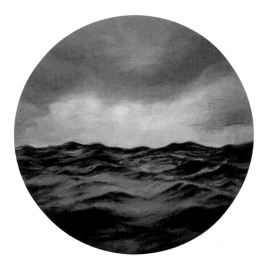

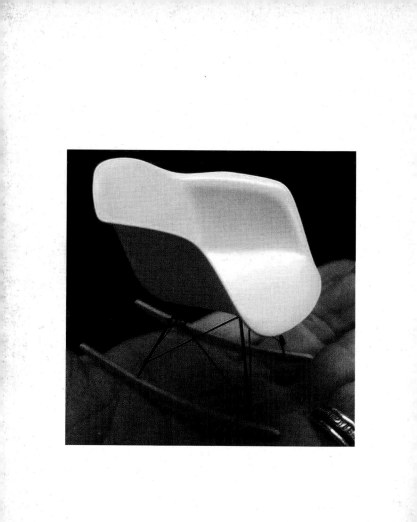

MICHAEL YURKOVIC

IS FORMALLY trained as an industrial designer. He graduated from the Cleveland Institute of Art and pursued a career in design immediately thereafter. About ten years in, he became familiar with the world of toy invention, where he was able to connect his love of vintage toys with the challenge of creating new concepts for that industry. This also further developed his prototyping skills, as demonstration models were necessary for nearly each of the hundreds of toy ideas he presented. Sculpting and illustration also became bigger parts of Yurkovic's world at this time, so things were definitely expanding on all fronts.

Q&A

WHAT COMPELLED YOU TO GO SMALL? I've always been captivated by objects in miniature, starting with model building with my father, then going to museums and seeing displays, all the while sharpening my own skills through my career as an industrial designer and toy inventor. Attending miniature shows made me aware of an absence in that world of objects from the mid-century modern era, so I applied my design background and highly developed hand skills toward creating replicas of classic furniture and accessories from that time period, one so dear to me!

CAN YOU GUIDE US THROUGH YOUR PROCESS FROM IDEA TO COMPLETION? If I'm doing a replica of an existing design, I will begin my process with research of both the specific piece of furniture and the designer associated with it. I love this phase, as it can often lead to surprises. I may find pictures of a rare prototype, or an image of the piece under development on the factory floor. This also lets me study all the details in materials and processes that went into creating a design. Getting to know the designer gives the piece context within the designer's wider body of work. From there, it's deciding on the best materials and processes to bring something to life in miniature. There is not always a direct translation in materials, so I try different options, experiment, and at times fail. As a piece evolves, I'm constantly checking the measurements against the prototype, as well as making sure it looks "right" to the eye. There are times when something may need to be accentuated in miniature to make it "read" in our world. Holding the finished piece is truly a joy each and every time. Ultimately,

each piece must stand up to my personal mantra: "The closer you look, the better it gets."

WHERE DO YOU LOOK FOR INSPIRATION? For much of my work I look to the design classics of the mid-century modern era for inspiration. My main body of work has concentrated on replicating works by such noted designers as Charles and Ray Eames, George Nelson, Eero Saarinen, and Isamu Noguchi.

Inspiration can come from so many other sources, though, so my eyes are always open for ideas, sometimes from the most unlikely of sources. Stopped at a train crossing, watching graffiti-laden cars rolling by, color combinations, shapes, forms—such rich turf! Walks in nature, seeing the natural interplay of organic forms. Architectural ruins are another great source. The interplay of man's creations with nature's return to the scene. This is actually the theme of some of my newer works outside the world of mid-century modern.

WHAT DO YOU FEEL CHANGES ABOUT YOUR PROCESS WHEN YOU WORK ON A LARGER SCALE? When working on a larger scale, I'm obsessed with the thought of, "What can I do in this scale that wasn't practical when the object was smaller?" Can there be more moving parts? How about peering inside a tiny access door, or a little window in greater detail? Perhaps different materials can be used to more accurately represent the real article. In short, it's about pushing myself ultimately to expand my skills, and to keep my mind open for clever little details to add to the picture and hopefully further draw in the viewer.

WHAT'S NEXT? While I continue to explore the mid-century modern era of design and architecture, I am also intrigued with the world of decaying structures and the concept of nature reclaiming the earth. As you know, the objects of the mid-century era are all very clean in design and finish by their very nature. While I enjoy this world, I'm also driven to replicate and explore rusted and worn materials often found in junkyards, in barns out in the country, or abandoned in urban alleys. There's an opportunity to dive into a narrative in these pieces, and that storytelling is something I find very engaging for both myself and my audience.

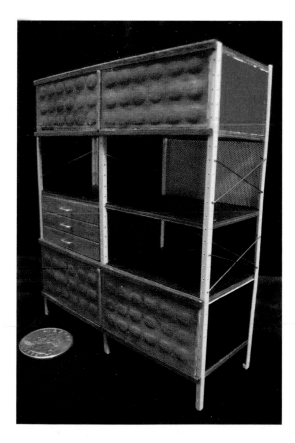

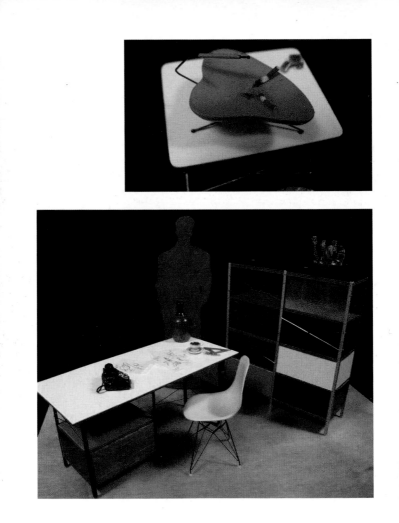

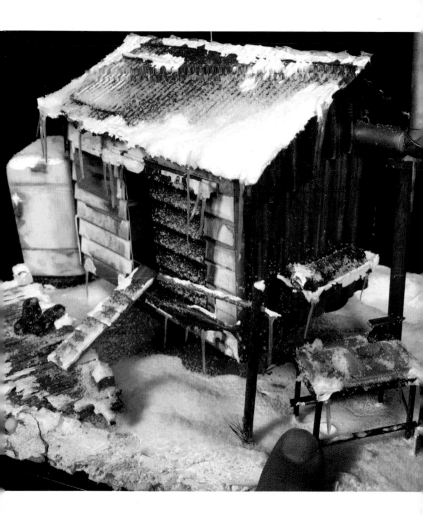

TAYLOR MAZER

IS AN art school graduate but credits his childhood growing up in the early '90s for much of his inspiration. A comic book lover from a young age, he attributes Batman's animated series with his decision to become an artist. He says, "The early '90s was such a great time to be a comic book fan, and growing up in that time made me the artist that I am today. If I had been born just a decade earlier, and had not gotten to watch the Batman animated series on a regular basis, I would have been a completely different person and probably never would have become an artist. I think the argument could be made that that show is the reason I draw what I draw."

Q&A

WHAT COMPELLED YOU TO GO SMALL? I prefer working smaller because it affords me the chance to do more completed compositions rather than bigger, time-consuming works. Instead of spending a week on one larger piece, I can spend more time thinking about composition rather than detail. Working smaller has the added benefit of being more personal. The idea that I have on the day I draw something may be forgotten or changed by the next day, but because these take so much less time I get to put the idea down in a completed form rather than a forgotten sketch.

CAN YOU GUIDE US THROUGH YOUR PROCESS FROM IDEA TO COMPLETION? I generally go out and take pictures of locations that I want to draw and come back to my studio and spend a great deal of time planning out my compositions. Everything in each of my drawings is done for a reason. I enjoy deconstructing things and figuring out how they are built, not only through their own physical structures but also how they interact with things around them, like dumpsters, cars, snow, uneven concrete or asphalt. Before I start to ink, I'll have my horizon line, my perspective point or points drawn, and the entirety of the subject matter laid out in pencil. Since ink is permanent, I take great care in making sure everything is drawn correctly in proportion and perspective.

WHAT ARE YOUR FAVORITE TOOLS? When I work in pen and ink, I use Micron drawing pens and a quill tip that is dipped in India ink. Each work is drawn on acid-free drawing or watercolor paper (the

ink's tone varies slightly when drawn on different papers). Working almost entirely with line allows my art to be constructed from the bottom up, so to speak. Even if I know an area will be covered in shadow, I still spend time drawing it out so later on I will be able to utilize my line work to show form as opposed to just value. I then go over the pencil in ink. Once the entire image is drawn out in pen, I begin erasing. Erasing the ink allows me to get line work in a full range of value instead of just black. I then draw over the erased ink and work my way forward from the furthest point in the background. I draw a layer, erase, I draw the next layer, erase, and so on. Toward the end of the drawing, I'll utilize other tools like dry brushing or pens with warm or cool gray-toned ink. I use light and shadow, signs, the direction of the line work, and placement of objects to focus the viewer's eye on particular objects, just as a comic book dictates a narrative through a page of panels.

WHERE DO YOU LOOK FOR INSPIRATION? Comic books. Even after going to art school and all the art history classes for a number of years, I still find most of my inspiration from comic books. I always thought the ability to convey a narrative in a picture or drawing is never utilized as well in other mediums as it is in comic books. More specifically, I find inspiration in the work of artists such as Kelley Jones, J. H. Williams, Jae Lee, Brian Bolland, Klaus Janson, Bruce Timm, Darwyn Cooke, David Mazzucchelli, and Lee Bermejo.

WHAT IS THE GREATEST PIECE OF ADVICE YOU EVER RECEIVED? When I was seventeen, I went to a comic book convention in Chicago and I got to meet a number of working comic book artists. It was the first time I had ever been exposed to people in that line of work. I very clearly remember talking to a couple of artists and showing them my work at the time and they told me that I have to draw twenty-four hours a day if I want to do this for a living. They told me I had to cut out everything else from my life except for drawing. I think they were trying to scare me, but it had the opposite effect. I really took that to heart.

WHAT DO YOU FEEL CHANGES ABOUT YOUR PROCESS WHEN YOU WORK ON A LARGER SCALE? Time. The bigger I work, the more time starts to exponentially grow. Early on, I would work larger than I do now because that was what I was taught to do. That was the norm. But as I continued to work and learned more about architectural drawing and how things are built, I started to shrink down the size of my work. The smaller the drawings, the closer the perspective points would be. When I work smaller, I'm able to concentrate more on composition.

WHAT'S NEXT? Drawing. I will be drawing for the rest of my life.

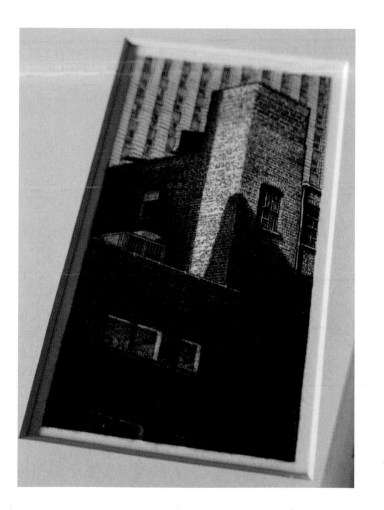

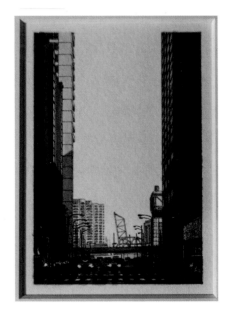

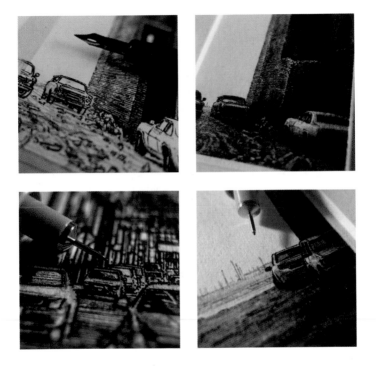

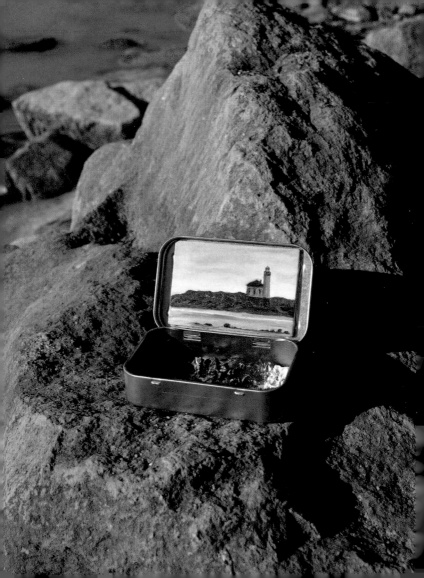

HEIDI
ANNALISE

IS A mostly self-taught artist. Like so many people, she enjoyed art as a child, but left it behind when she graduated from high school. She didn't pick it up again until her late twenties, when she signed up for an oil painting class on a whim.

Q&A

WHAT COMPELLED YOU TO GO SMALL? When I was a child, I was obsessed with all things miniature, especially my Lego village. One of the imaginary residents of that village was a young artist, so I decorated her room with all the typical artsy trappings, including a couple of Lego-size watercolor paintings, both tiny landscapes, that I painstakingly created with the smallest brush I could find. There was something so satisfying about creating a tiny object that could be a whole world unto itself.

Years later, when I took up oil painting, I was self-conscious about the idea of dragging full-size equipment outdoors and making myself a spectacle for passersby. I noticed another artist on Instagram, Western painter Glenn Dean, using a mint tin for small sketches, and I immediately identified with the concept. It was perfect for me, combining both my love of tiny things and my desire to be a sneaky, covert painter! This kind of painting gave me the courage to go outside and just start painting.

CAN YOU GUIDE US THROUGH YOUR PROCESS FROM IDEA TO COMPLETION? The beauty of my tiny plein air paintings is that they get me out of my head—away from plans and processes. I'm usually short on time, and sometimes there are other environmental factors to contend with, such as harsh sun or wind, and that means I need to dive into the painting headfirst. I think the most important factor is choosing the composition and visualizing it on a small scale. I still have to redo the early stages of paintings quite often because I failed to "zoom out" far enough with my composition, and subsequently ran out of space! In those early stages, I'm mostly blocking in the darkest parts

of the image to create a basic drawing before getting too distracted with color mixing.

WHERE DO YOU LOOK FOR INSPIRATION? I'm grateful to live in the beautiful state of Colorado, where inspiration abounds. I also love taking road trips in search of new ideas.

WHAT DO YOU FEEL CHANGES ABOUT YOUR PROCESS WHEN YOU WORK ON A LARGER SCALE? Ironically, I feel less inclined to include details when I work on a larger scale. I also tend to overthink my compositions and color choices in the studio. I feel like there is a noticeable enthusiasm captured in my mini paintings that sometimes gets lost on a big canvas. Of all my art, they bring me the most joy, and I think that in some mysterious way, people seem to recognize that.

WHY ALTOIDS? Altoids mint tins are the perfect size! You can slip one into your pocket and go for a hike, or toss one in the glove box. They're lightweight, yet strong enough to protect the contents. The only thing I haven't quite figured out is what to do with all the extra mints.

WHAT'S NEXT? I'm going to spend a few months working on my fundamental drawing and painting skills, and continue to challenge myself with large-scale projects, because that's where I see the most potential for growth. The mint tin paintings will still make frequent appearances, because they are my playtime and an amazingly meditative way to sit quietly in nature.

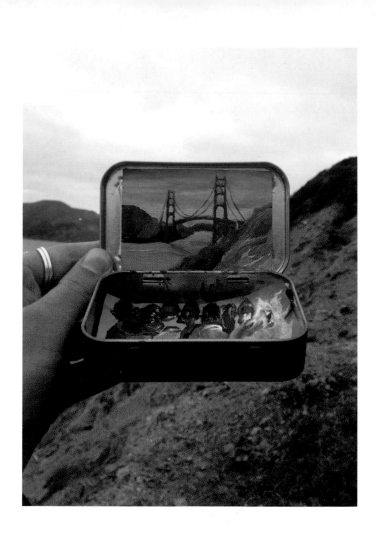

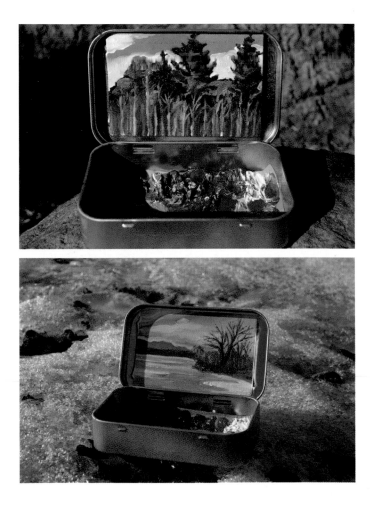

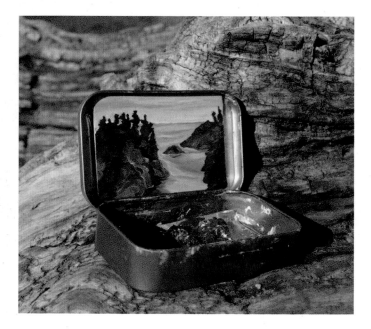

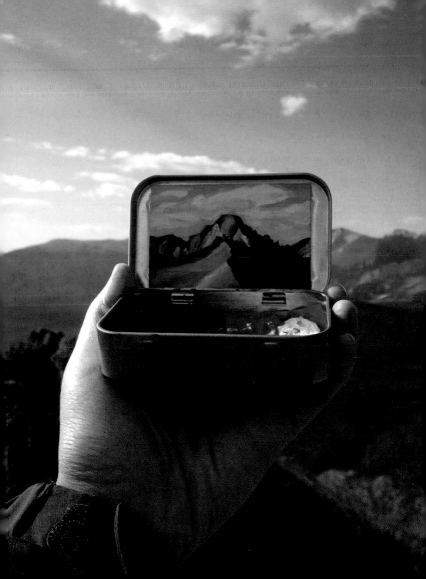

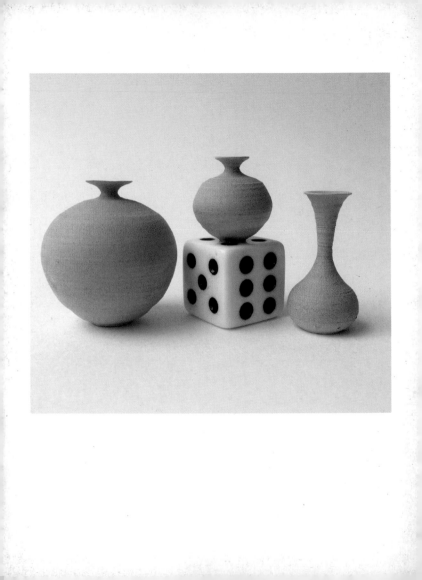

JON
ALMEDA

IS ESSENTIALLY a self-taught ceramicist. He was first introduced to the pottery wheel in high school, but wasn't given much instruction. Entranced by the whole process, Almeda decided to buy a wheel when he graduated. He has been throwing ever since.

Q&A

WHAT COMPELLED YOU TO GO TO SUCH A SMALL SCALE?
I have always had an affinity for scale, whether it is oversize objects or perfect miniature replications. It was really just the challenge of working small that drew me in. Before I started working small scale I was producing very large works; quite frankly, I was a little tired of always trying to throw bigger pieces. Working small really allows me to focus on shape and scale and the relationship between the two.

CAN YOU GUIDE US THROUGH YOUR PROCESS FROM IDEA TO COMPLETION? Each piece gets thrown on either the Curio Wheel (the miniature wheel I designed and built) or a full-size potter's wheel. Before starting, I choose the clay body, which will determine what type of firing process I will do. If I choose a porcelain clay body, those will usually become crystalline pieces. Crystalline is a glazing/firing process where crystals grow during the kiln firing. When choosing an earthenware, or low-fire clay, I will use a raku technique. Raku is a sixteenth-century technique where pieces are pulled out of the kiln while still red-hot. Every piece goes through the same steps as a full-size piece.

ARE YOU EVER TEMPTED TO GO BIGGER? I mainly work in small scale, but I do produce full-size works. For me, it is important to work in all scales. Creating small works has made a tremendous impact on my bigger pieces. I am infinitely aware of the subtleties of a great piece. It has definitely made me a better full-size potter.

WHAT INSPIRES YOU? Hans Coper, Lucie Rie, Gertrud and Otto Natzler, and Rose Cabat are just a few of my favorite potters. Their work was fresh and innovative at the time, and still continues to be.

WHAT'S NEXT? I am in the early phases of a reproduction series. The focus of the series is highlighting some pieces from amazing mid-century modern studio potters. I am fascinated and inspired by many of the artists who were producing during that time.

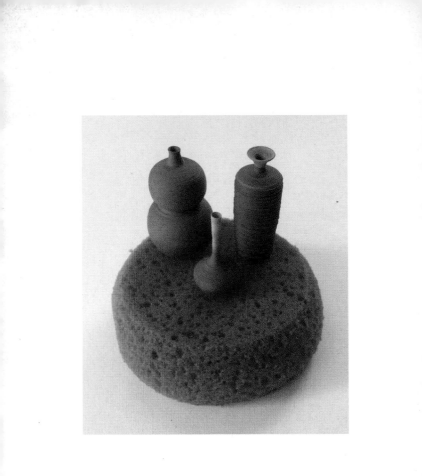

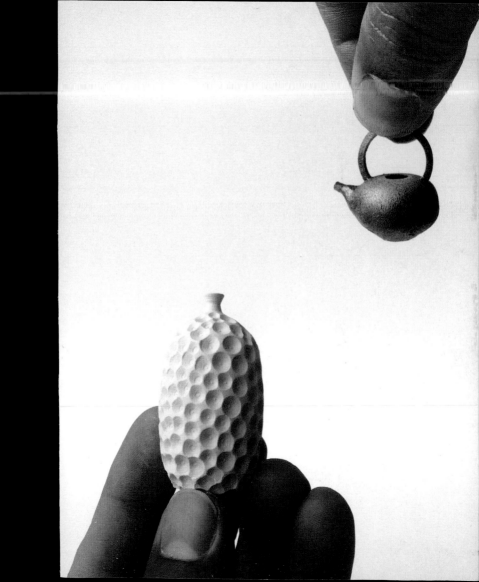

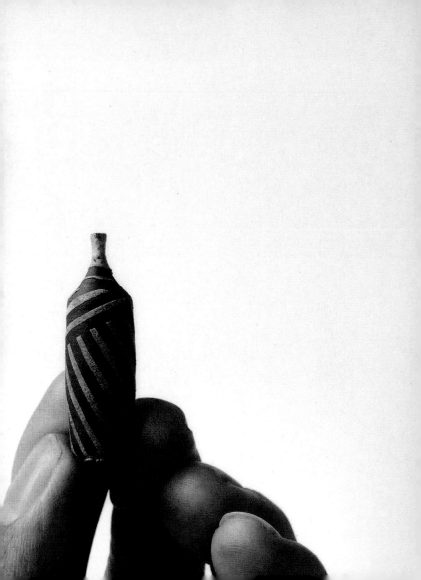

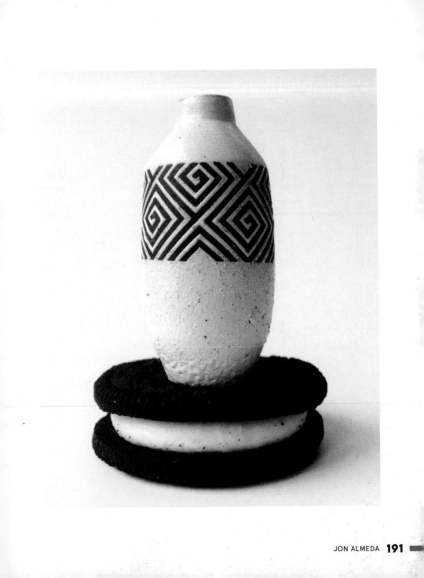

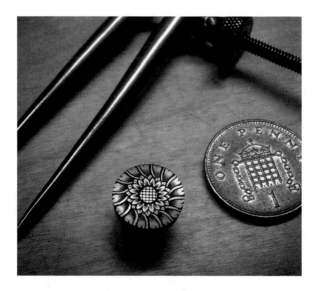

JOHNNY

"KING NERD"

DOWELL

STUDIED ART in college in the United Kingdom with the hopes of pursuing a career as an artist. Some time during his studies, he came across a brochure for one of the largest gun manufacturers in the world that specializes in bespoke guns with intricate hand engravings. He convinced them to train him, something they'd never done before, and after five years, he became an expert in engravings large and small. He works with many mediums, including watch bezels and coins.

Q&A

WHAT COMPELLED YOU TO GO SMALL? I've always been fascinated by the whole story of currency and how it literally makes the world go 'round and how it's a part of our everyday lives. I also love the journey of currency, and how it makes me think about where it has been. For instance, a coin I've hand engraved may at some point have been held by someone near me before I engraved it.

CAN YOU GUIDE US THROUGH YOUR PROCESS FROM IDEA TO COMPLETION? My idea for each coin can be one of three things. It can be either something I'm really into that I do a coin collection of, something very current and maybe newsworthy, or something weird and wonderful. I'll draw the ideas on paper first, transfer them to the coins, and then hand engrave, combining traditional hand engraving with inlay of sterling silver, platinum, and 24k gold to make them even more different depending on the subject matter.

WHERE DO YOU LOOK FOR INSPIRATION? It sounds really corny, but my inspiration comes from a lot of places. Saying that, I admire the likes of Takashi Murakami, Shepard Fairey, KAWS, Jeff Koons, and Ai Weiwei, as well as manga, pop culture, even vinyl toys. I love Japanese culture and American comic and film culture. Then on the other hand, I love engraving something that's going on at the moment that makes people think, like my *Trump We Trust* coin I did literally a month before he won; some thought it was great and hilarious and others were angry I had defaced JFK!

WHAT DO YOU FEEL CHANGES ABOUT YOUR PROCESS WHEN YOU WORK ON A LARGER SCALE? The process never changes much; it just becomes lots more engraving, designing, and general drawing the bigger the canvas is.

WHY COINS? The reason for now basing my art around coins is because I always was trying to literally do everything—sketch, paint, build, photograph. I love all those art forms, but I wanted to create my own thing and stick with it. Then one day the penny dropped (no pun intended); everyone kept telling me my gun and watch engravings were like art, and I just thought, why don't I turn coins into my canvas? I thought long and hard about how I could take coins and give them the exact same feel as an expensive painting. So my idea now is every coin comes with a blown-up art print of the signed coin. There's only ever one coin and one original print to accompany it. The coins are so small, so the print lets people look from a distance and discuss it like a painting, and also there's only one print, like those famous paintings you love but can't have because they're owned by someone else and there's only one.

WHAT'S NEXT? I have so many ideas in my head for the next project, but like most artists, I just need to pick one already and do it! I don't want to give too much away actually, because this kind of art seems to work so much better when people see the end product without knowing what's coming, if that makes sense.

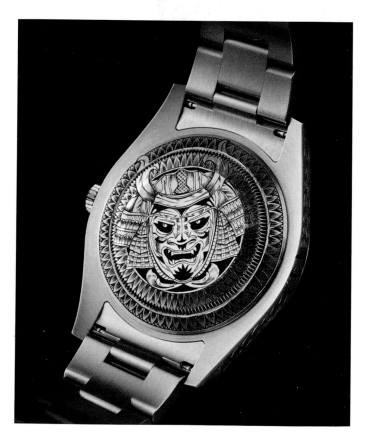

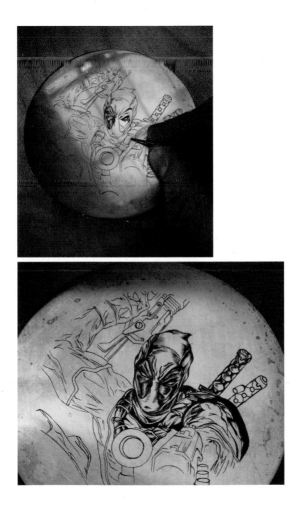

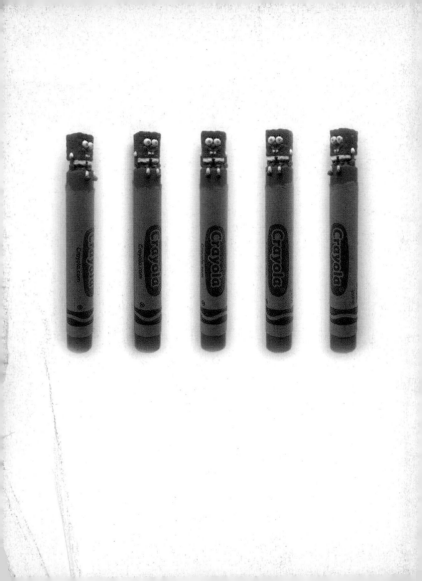

HOANG TRAN

SPENT THREE years in dental school before he decided to withdraw because he wasn't passionate about dentistry and didn't want to spend the rest of his life doing something he didn't enjoy. He has no formal art training, but uses his mastery of dental tools and techniques to carve crayons.

Q&A

WHAT COMPELLED YOU TO GO TO SUCH A SMALL SCALE?
I wanted to try to find a career that involved more creativity. Around this time, my friend was putting on an art show and asked if I wanted to participate. I thought about what I could make and remembered seeing another artist's work online a while back where he carved animals out of crayons. This stood out to me when I saw it because I had already been doing something similar in dental school, where we had to carve teeth out of wax. The medium was similar, and I already had the hand skills and tools, so it seemed like a natural fit.

WHY CRAYONS? I like working with crayons because they are something almost everyone has had experience with. People know how small and fragile crayons are, so they can have a greater appreciation for the challenge of carving them. I also like the idea of taking something common and working with it in a new way to elevate it to something more special. The bright colors are also a plus.

CAN YOU GUIDE US THROUGH YOUR PROCESS FROM IDEA TO COMPLETION? The majority of the work I do is made for customers, so usually the idea isn't even mine to begin with. However, I do have to decide first whether the idea is doable. I always carve the crayons vertically oriented, because they can naturally stand up that way. Because of this, narrow or tall subjects usually work very well. Something wide like a car wouldn't be ideal because it would end up very small on the tip of the crayon. I also avoid subjects that are really

narrow or have thin parts because they are liable to break during the carving process or after completion.

Next, I decide which color crayon to use. Usually it's simply determined by the main color of the subject. However, sometimes the subject is a few different colors and one doesn't dominate, so I have to figure out which color would make the creation process easiest for me. The extra colors I apply to my carvings come from wax from other crayons, which I melt and carefully apply. When I do this, the underlying crayon tends to melt and bleed a little into the wax I'm applying, which I don't want because it alters the color. Thus, I try to choose a lighter color base crayon if possible so that a lighter color bleeding into a darker color is less noticeable.

Once I have the subject and the color, I can start carving. I was in dental school, so I use dental instruments because that's just what I'm used to using. I also keep a small paintbrush handy to brush away wax shavings from the crayon and my tools. I don't sketch or draw out my plans; I just go for it. I do scratch out lines on the crayon itself as guides, though. I then rough out the basic shape and refine from there. If I need extra colors, I'll apply them via melted wax. After it cools, I can proceed to carve it as usual. The melted wax is mainly used to color an area, but I also use it to bulk out or build volume where it's needed.

Once everything is done, I take a lot of photos of the finished product for my own records and to share on social media. Then I usually pack it up and ship it off to the customer or gallery if it is for an art show.

ARE YOU EVER TEMPTED TO GO BIGGER? I've been given large novelty two-pound crayons as a gift in the past. I have thought about carving them but haven't done so yet. Carving small crayons is my strong suit, and I think going bigger wouldn't necessarily be an easy transition. It's like asking a sprinter to run a marathon. Even though both activities seem similar, they are very different things. Although I know the medium well, I wouldn't be used to the scale.

WHAT INSPIRES YOU? I'm a pop culture junkie, so I like drawing from TV, film, cartoons, and comic books. If the subject is something I like, then I have a better understanding of how it should look. It makes carving more enjoyable and I try harder to honor the subject as best I can. In the end, I know I've done a good job when I want to keep the carving and not send it away.

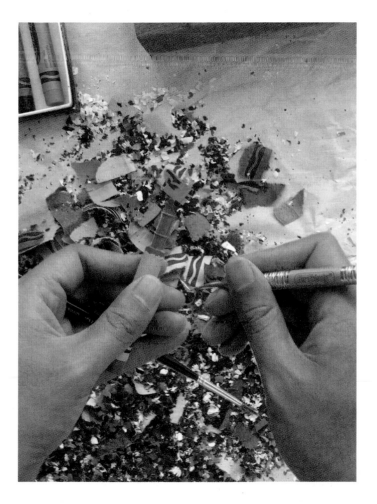

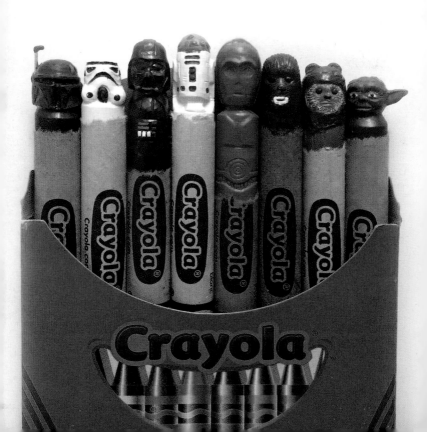

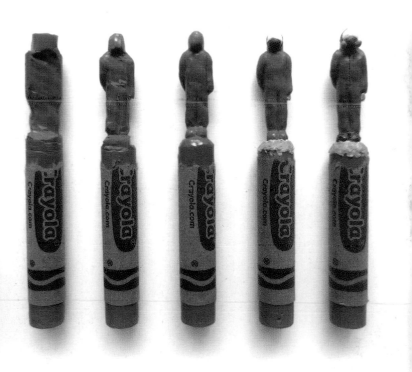

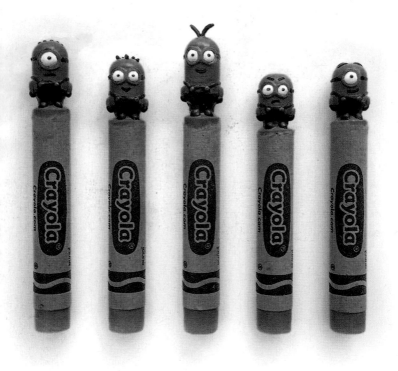

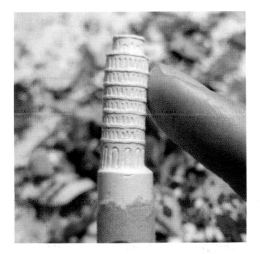

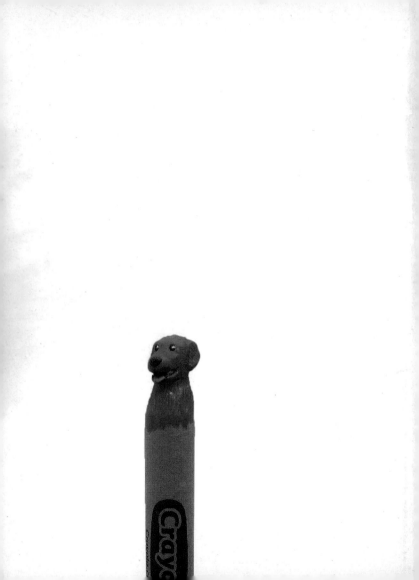